BLACK FRIDAY

11.25.2011

Forward

"If an authoritarian agency believes itself to be under attack, or under the threat of attack… and it is in the public limelight because of this, it will lash out in a less than predictable way. It may act in a manner that is injurious to itself, but it is just as likely that it will act in a way that could endanger unsuspecting elements of the public sphere." –from Critical Art Ensemble's *Digital Resistance*

Black Friday is the unofficial shopping holiday that sweeps across the United States on the day following Thanksgiving. The name was first used in 1966 by a news reporter to describe the "mobs" of shoppers in the downtown area of Philadelphia. In an attempt to shed this title of its negative context, there has been a recent push to suggest that "Black" refers to the businesses' move away from the red digits of debt. Since 2005, the day is infamous for bringing unanimous profit to any store with open doors. At first glance, everyone appears to get what they want. Black Friday maintains a responsibility for reviving the interest of those who would otherwise lack the excuse to make those bigger purchases. Our houses and the bodies that fill them are adorned with the more glamorous product at a fraction of the cost and a host of companies are relieved of their economic dues.

The last Friday of November is a day when the American-Capitalist expectations are supposed to be met. Why then, at the sun's setting on November 25th, 2011, did so many of the shoppers express an unabashed lack? Even as I write on the following Monday, I experience the trickling effect of dissatisfaction. Headlining news reminds us all that Black Friday has spawned another wealth-transferring offshoot… "Cyber Monday". Outweighing Friday's reports of fiscal jubilee are the tales of violence and armed criminal activity over video games and flat-screen televisions. Despite the collective-consumers' most valiant effort, the globalized economic swing-set continues to display tumultuously bad behavior. Those of us who emerge from the shadow of the valley of deals can say with great ease that those prospects were quickly evaporated. The wrath of chance in combination with the unpredictability of amassing hoards will always prove no match for expectation.

On November 25th, 2011, Garett Yahn and I led eleven zealous artists to New England's second-largest shopping center. Brimming with a plan to meet my own expectations with a few activist/artistic gestures, I was among a small group of individuals who set out to inject a few provisions into the greater authorial goals for the day. In combination with a healthy dose of paranoia, our curatorial goals were fueled by an idea put forth by the quote used at the beginning of this text. We prefaced the day with one main condition: all actions were to remain subtle. We hoped to avoid mass detection. We hoped to tactically insert ourselves in line with the many who shared the space of the mall. There was no intention of becoming destructive towards said "unsuspecting elements of the public sphere." Our arrival at the mall was shrouded by the initial illusion of complacency. We appeared as though we were there for the same reasons as everyone else.

We perpetuated our own sets of expectations. Both were shaped by our physical contributions to our surroundings. The following pages are filled with those contributions… by our reactions to fulfilled and failed expectations.

- Jordan Tynes & Garett Yahn

Artists:

Erik Benjamins
Jessica Borusky
Leah Craig
Alaina Gurdak
Taylor McVay
Anthony Montuori
Miles Pflantz
Nina Prader
Chris Soldt
Joanna Tam
Jordan Tynes
Garett Yahn

Erik Benjamins

Sitting under the shade of artificial palm trees, I lean against a metal trunk to read and write.

EXPERIENCING SPACE:[1]

CONFLATION OF SPACE AS MOTIVATING US, AND US MOTIVATING AND FORMING SPACE.[2]

TEMPORARY COMPLICATION OF SPACE/PLACE CONVENTION WITH MOVEMENT-PERFORMANCE, RE-INSCRIBING NEW MEANINGS THAT COME FROM THE CHOREOG. — TO THE AUDIENCE — TO THE SPACE.

AND ACKNOWLEDGING THE VAST SENSORIAL IMPACT WITH SPACE. EPISTEMOLOGICALLY, PHYSICALLY, CULTURALLY,[3]...

SO, THE OPPORTUNITY FOR ANTAGONISMS. INTERRUPTIONS, GUIDED BY AND INSTIGATED BY SITE. THE NATICK, BLACK FRIDAY. AND ITS ESSENCE, ITS 'NESS' — ARCHITECTURALLY, SPATIALLY, ECONOMICALLY, SENSORIALLY, SOCIALLY, POLITICALLY.

└ TO MAKE/PROPOSE A CHOREOGRAPH, DANCE FOR THIS UNIQUE CONTEXT. ONE THAT RE-INSCRIBES THE SPACE TEMPORARILY THROUGH INTERRUPTION, DESIRE, EXCITEMENT, SADNESS, LAUGHTER & FEAR.[4]

LOGISTICS: TWO PEOPLE(?) DURATIONAL[5] OR REPEAT.[6] SCENT DRIVEN. PROPOSAL BASED. ROMANTIC (HOPELESSLY) ARCHITECTURALLY SPECIFIC. PHYSICALLY ENDURING. SPECTACULAR (AT TIMES?) SLOW, STILL.[7] VERBAL.[8]

[1] *Experiencing Space: The Implications for site-specific dance performance* by Victoria Hunter. I photocopied the essay at Tufts and forgot the book it came from!

[2] Context: Black Friday in Natick. Collapsing the buying of things with the thinking of things and the motivation is like a juicy pear, almost too ripe, too soft, soon to brown.

[3] Capitalizing on the senses and sensual for the re-imagining of the New England shopper's paradise. What does Black Friday Natick taste like? How do we move through, among, within and on the edge of it? Adjectives to describe an energy. Try not to depend on your eyes.

[4] When are interruptions savored? When are they loathed?

[5] *YOUR* TIME

[6] *YOUR* TIME!

[7] In dance, the verbal can apprehend you with a force like that cop waiting along that goddamn speed trap along Loynes Drive!

[8] See the intro in *Exhausting Dance* (2006) by Andre Lepecki – he beautifully adopts Nadia Serematakis' beliefs on stilless and the still-act, applied towards movement: "a corporeally based interruption of modes of imposing flow."

~~If you think about~~ Imagine the Natick Collection your Algebra I teacher. You are the student. You have failed another test. ~~And you know you're going to get asked to stay~~ "Could you stay after class for a moment today?" the teacher says. ~~So~~ What's to follow after class is undoubtedly a conversation we can describe as 'one way'. This is the ~~~~ model Hunter, I believe is getting at. A model where you, or I as I sit here, are spoken to. Spoken at. A one way exchange. ~~So~~ To re-imagine the site for alternative usages, we can begin the slow process of re-interpretation. Or ~~adding at least adding another voice to the conversation; speaking back.~~ ~~So to perform in a site loaded with~~ The audience sees the dance. The re-coding of a site with content, movement that complicates, contradicts what the space wants to tell us. And then meaning becomes unfixed. Loose. Messily floating.[9]

A score for a dance. — Movement phase one

~~Two~~ Four dancers, wearing street clothes enter the Natick, ~~from~~ each from ~~a~~ one of the N, S, E or W entrances

N (Neiman Marcus)
S (Lord + Taylor)
E (Sears)
W (Macys or JCPenny)[10]

To begin, the performers enter from each of the four points of entry at Natick: north, south, east and west. Each performer will do the routine four times, once from each entryway. Four approaches, four times to seek out with an athletic dependency on peaked nostrils, the expected and unpredictable, the desirable and repulsive, the familiar and foreign qualities of the Black Friday Natick experience.

[9] The dregs of an essay I attempted to write, under that fake oasis on the first floor. Lots of cross-outs, x-outs and re-dos. I read Victoria's essay and planned to use the rest of the day to cultivate some thoughts. Seated, mildly uncomfortably, I was stationed, neck crooked and hand writing among the steady flow of shoppers. One thought led to another and I used most of the day instead to propose some choreography.

- THE CENTRAL MEETING POINT IN THE NATICK COLLECTION WILL BE THE LARGE FOUNTAIN ON THE FIRST FLOOR.[11]
- THE ~~DANCERS~~ PERFORMERS WILL WALK 50% SLOWER THAN NORMAL SPEED ~~UNTIL THE~~. AS THEY WALK THEY WILL BE EXTRA SENSITIVE TO SMELL.[12]
- ~~WHEN THEY HAVE ENCOUNTERED~~ THE FIRST SMELL THEY ENCOUNTER THAT THEY FIND EXTREMELY POTENT[13] ~~AND~~ AFFECTING THEY WILL STOP. THEY WILL TRY TO PERPENDICULARLY CONFRONT[14] THE SMELL AT ~~ITS~~ ITS PERCEIVED ORIGIN AND BEGIN ~~THE~~ MOVEMENT PHASE TWO.

 STAND WITH FEET TOGETHER
 SLOWLY BOW DOWN AND INTENSELY TAKE A
 NOSE BREATH. LIFT YOUR BODY SLOWLY UP

AND WHEN YOU'VE REACHED THE TOP SAY 'AAH' IN A LOUD, STRONG ASSURING TONE.[15] SMILE.[16] SLOWLY SLOWLY ROTATE IN A 360° MOTION AND WHILE DOING THAT SCREAM[17] AS LOUD AS YOU CAN. NOW WALK[18] TO THE MEETING POINT. AT THE FOUNTAIN ~~YOU~~ EACH PERFORMER WILL STAND CLOSEST TO THE ENTRANCE THEY HAVE ENTERED AT.[19] SO IF YOU'VE ENTERED FROM S (SEARS) YOU WILL STAND AND WAIT AT THE S SIDE OF THE

Subjective of course. Running the spectrum from aggressor to seducer. Or perhaps both? A provoker.

11 The fountain consists of two large, skinny-eye shaped forms. Water bubbles gently across smooth granite. Pretty impressive, but triumphantly overshadowed by a steadily moving green belt that conveys sushi in different sizes, shapes and tastes. I think the restaurant was new. There were long lines over the day. Sushi moving at a slow pace, into cupped hands with sticky fingers.

12 Guided by nose. Pedaled by feet.

13

14 *High Noon*! A Western showdown. A standoff, not against an enemy, rather an unexpected and welcomed interrupter, happily perceived by the one moving slowly, taking time.

You're thankful, but overdoing it. Three clicks past comfortable, veering into unsettling .

15 **16** With confidence!

17 The passerby, now jostled and shaken.

18 *Walking: the intentional act closest to the rhythms of the body. Delicate balance between working and idling, being and doing. A bodily labor producing thoughts, experience and arrivals. An action when, ideally, the body, mind and world are aligned in conversation. Walking and falling, the potential for catastrophe.* Notes taken from Rebecca Solnit's *Wanderlust* (2001).

19 Arriving and waiting. A reception at the fountain unison!

FOUNTAIN. EACH PERFORMER WILL WAIT AT THEIR RESPECTED SIDE UNTIL ALL FOUR ARE PRESENT. WHILE EACH PERFORMER IS WAITING THEY MUST BE ~~VERY~~ SILENT, AND IN HIGH ATTENTION TO SEE WHEN THEIR OTHER THREE COHORTS ARRIVE. WHEN ALL FOUR ARE THERE, THE LAST WILL RAISE ONE ARM (1), RAISE SECOND (2), LOWER ONE (3) → GO ~~TWO FROM THREE~~ TO ONE AND AT ONE EACH PERFORMER WILL RUN TO THEIR PARTNER AND EMBRACE. THEY SHOULD RUN FULL SPEED AND EMBRACE LIKE ~~TWO~~ LOVERS ABOUT TO PART WAYS.[20] AFTER THE EMBRACE THE PERFORMER WILL RUN AS FAST AS THEY CAN[21] TO THE EXIT THAT IS ONE MOVEMENT CLOCKWISE OF THEIR ~~EXIT ~~ PRIOR ENTRANCE POINT I.E S→W, N→W. THE SEQUENCE WILL START OVER AGAIN, MEANING THAT EACH PERFORMER WILL COMPLETE THE OVERALL SEQUENCE ~~AT EACH~~ STARTING FROM EACH RESPECTED ENTRANCE ~~MEANS~~ POINT.[22]

20 A momentary pause and rest to console, reassure, and egg on. Emotional re-fueling.

21 And then off. Sprinting across shiny floors, bounding past shoppers and palm tree sitters at full speed, cheeks flapping, hair matted back like the dude in the black suite, sitting in the leather sofa confronting the Bose(?) entertainment system.

22 It's going to be pretty athletic so you should train up a little. Build up some endurance and patience. It will be tough and ask a lot from you. Cultivate the willingness to *take time*. And maybe that willingness will turn into a desire, a nag or bead of drool. Now we can start getting somewhere, towards an alternate epistemology. Towards the Hungry Traveler, experiencing, conversing and learning with the stomach.

Sitting under the shade of artificial palm trees, I lean against a metal trunk to read and write
(A proposal of choreography to be performed on Black Friday at the Natick Mall, Natick, MA).

Erik Benjamins, 2012

Jessica Borusky

Understanding the Margins of Jessica Borusky
on November 25th, 2011.

Setting out to understand the margins/limits/possibilities of my body through the measuring and conversation between mall associates and myself, I re-inscribed myself back into a workforce I have spent years in; albeit through the contextualized drag role as buyer.

What resulted was conversation/touch regarding my/their body that drudged up an internal consideration about the connection between (the desire for) normative physicality and consumerism. Playing one role - though not purchasing anything - of interested customer, allowed me to also remind myself of the genuine fear and happiness that comes from playing the role of the seller: how to make us/you/me feel good about this transaction and what do we/you/me gain and loose in doing so?

Though many interactions between sales associates and myself occurred throughout the day, these five cards and information where the most complete (in terms of card and text) remnants of the performance.

1. Victoria's Secret: Two bra specialists measured my bra size. Kim thought I was a 32 B, while Nicole insisted I was a 32 C. We all agreed, smiled, and laughed that the most flattering style was the Gorgeous Demi.

2. LensCrafters: The manager measured my pupil distance. Though I am confused as to what her numbers represent in regard to my pupil distance, I trusted her tone and analogue machine.

3. Sunglass Hut: Everyone in the store got excited to show me sunglasses that would look great on me. The two styles that looked the best via the employees input included two Ray Ban styles- numbers 3016 and 3025.

4. Origins: Kate showed me a skin care line that best fit my lifestyle and age. She allowed me to sample the products so that I could feel it on my skin. She also told me about the ingredients, which I appreciated. She was a smoker and an art teacher prior to working at Origins. She liked Origins more, though.

5. Stuart Weitzman: Melinda measured my feet. My right foot rests between the United States shoe size 6 ½ and 7. My left foot rests between a 6 ½ and 6. My feet did not fit into the 500$ shoes, however. Its ok, Melinda's didn't either.

1.
YOUR PERFECT FIT
VICTORIA'S SECRET

2.
LENSCRAFTERS

LUXOTTICA NORTH AMERICA
LENSCRAFTERS
1245 Worcester St
Natick, MA 01760 USA
Tel. 508 653 0322
Fax 508 653 0375

3.
sunglass hut

SUNGLASS REPLACEMENT DISCOUNT
REGISTRATION CARD

Product Purchased: _____
Purchase Date: _____
Transaction #: _____

E-Mail: _____@_____
Last Name: _____
First Name: _____
Address: _____
City: _____ State: _____ Zip: _____ Country: _____
Phone # (_____) _____
Date of Birth: (MM/DD/YYYY) _____

4.
Another gift for you.
FREE Mini Facial.

ORIGINS
Powered by Nature. Proven by Science.

5.
STUART
WEITZMAN

Melinda King
Store Manager

1.
Jessica
32BC

BRA SIZE PANTY SIZE DATE

YOUR MOST FLATTERING STYLES:
PUSH-UP DEMI
☐ BioFit Push-Up ☐ BioFit Demi
☐ Body by Victoria Push-Up ☐ Body by Victoria Demi

We're so pleased to have helped you find your perfect fit.
Keep this close and present it to a Victoria's Secret associate
any time you shop for a new bra.

STORE ASSOCIATE Nicole
CALL ME WITH QUESTIONS AT

2.
Right - 29 1/2
Left - 28 1/2

3.
RB3016 $144.95
8052893653660

RB3025 size 55 $139.85
8052893004783

4.
Let us treat you to a Kate
Mini Facial. It's FREE!
Book at your convenience.

Includes:
+ Personalized consultation
+ Nature's gentle dermabrasion
+ Mask for your special task
+ FREE sample of your choice

To find an Origins location near you, visit origins.com
or call 1-800-ORIGINS (select #2).
And remember to bring this card to your appointment.

508-647-4782

5.
R - Right Below 7, Above
 6 1/2
L - Right Below 6 1/2 Above
 6

Leah Craig

Black Friday Yoga is an instructional pamphlet that details physical yoga poses and breathing techniques intended to counteract stresses experienced by those directly and passively involved in the periods of intensive, frenzied consumption that characterize Black Friday.

Prior to the event, I interviewed people that had participated as shoppers on previous shopping holidays. I also observed the bodies of people shopping at various locations, noting their physical movements as they stood in lines, browsed product selection, and otherwise physically engaged in their shopping experience.

Drawing on these observations and interviews, as well as my experience as a yoga instructor, I created a sequence of poses that could be conveniently executed within various mall settings. I then distributed the pamphlets in a discrete manner among fitting rooms, bathrooms, kiosks, and shelved products on the day of the event.

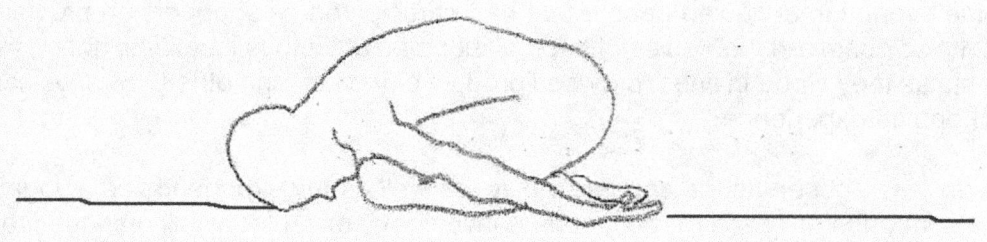

Balasana

* Avoid this pose if you are pregnant or have knee injuries

Kneel on the floor
Separate knees to about the width of a shopping-bag (approximately 6 inches apart)
Bring big toes together
On an exhale, fold forward and bring forehead to the floor (or to a folded garment of floor is too far away)
Extend arms out in front of body, palms on the floor, hips to the heels
Breathe slowly and deeply through the nose for 10 breaths
Release

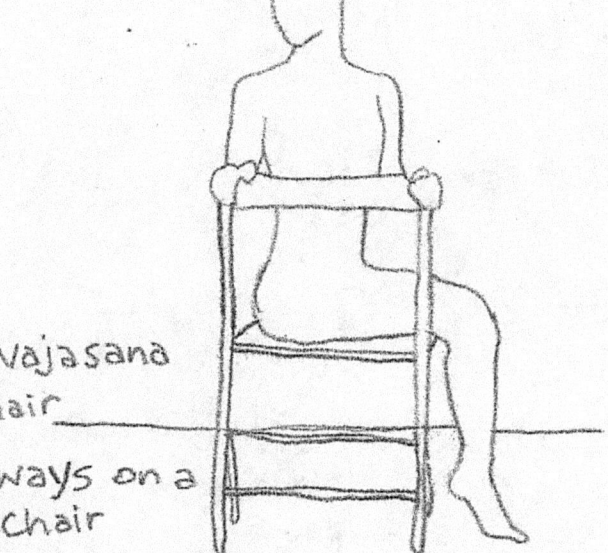

Bharadvajasana in a chair

Sit sideways on a stable chair

Bring knees together — make sure heels are directly beneath the knees

On an inhale lengthen the spine

Keeping the spine long and torso lifted, exhale and twist toward the chair back

Place hands on the chair back with elbows bent and lifted to the sides

Very slowly repeat the inhale/lengthening motion and exhale/twisting motion

Exhale to slowly untwist, and take the same steps on the opposite side

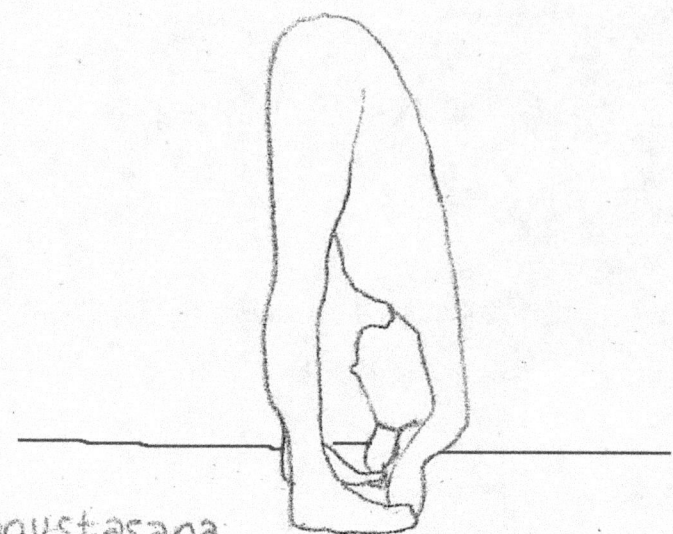

Padangustasana
Stand with feet parallel and about hip-width distance apart, with toes directly in front of heels
Inhale and lift torso to lengthen spine upward, hands on hips
Exhale to fold forward, hinging at the hips, back is as flat as possible
Bend the knees as much as needed and bring hands to rest on shins
Inhale and lift chest until arms are straight, spine lengthens
keep back of neck long — look to the floor with eyes
exhale and lift sits bones up toward ceiling and fold forward again
keep spine long, do not round
Breathe slowly and deeply through the nose for five breaths

Release

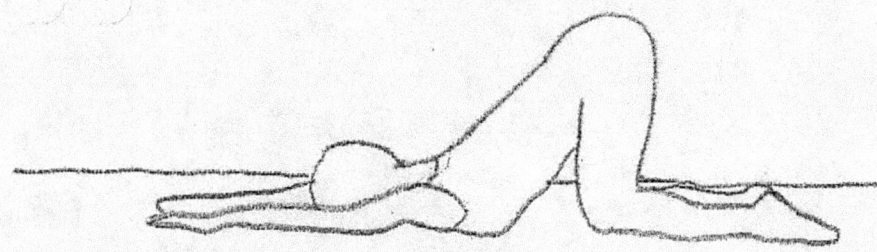

Uttana Shishosana

* Avoid this pose if you have knee injuries

Come onto palms and knees with shoulders above wrists and hips above knees

Extend arms forward and bring forehead to the floor or to a folded garment

Exhale, extend the hips back toward the knees

Breathe slowly and deeply through the nose for 10 breaths

Release

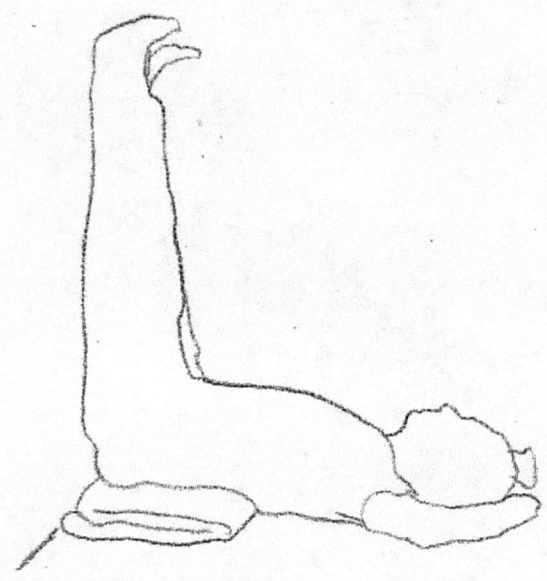

Viparita Karani

* Avoid this pose if you have serious eye, neck, or back problems

Place a pillow or folded garment about 6 inches away from the wall

Sit sideways on one end of the support
Exhale and gently swing your legs up onto the wall
Gently lower shoulders and head to the floor
Allow legs to relax, belly to soften
Breathe slowly and deeply through the nose for 5 minutes

Release

BLACK FRIDAY YOGA

Alaina Gurdak

Alaina's World Thoughts Goes to Black Friday

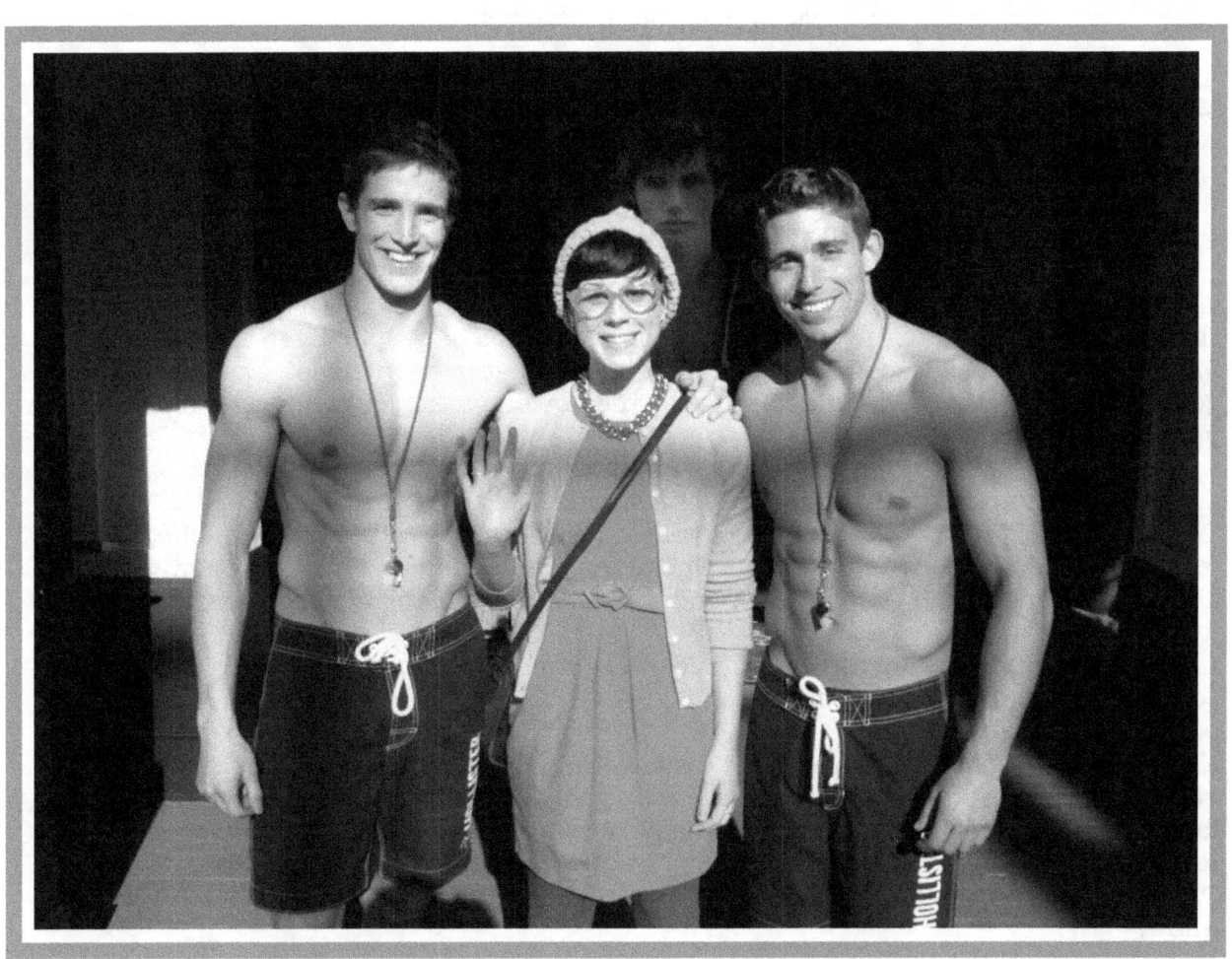

February 4, 2012

Hello!

I know it's been awhile since the darkest Friday of the year, so I first want to say "thanks a bunch" for allowing me some time to digest what happened at that very large mall last day-after-Thanksgiving. You see, given my Alaina's World Thoughts quest to try and figure out how to make the world a bit better, I jumped (literally) at the chance to see what would happen if I went into Black Friday for the people instead of the deals. I simply wanted to go, be friendly, and re-focus some of the consumerist five-hour-energy toward niceness toward others.

It wasn't easy. No siree. At first, I planned to ignore barcoded items completely, but that idea was nixed within the first hour. Talking to people can be hard unless you have something to say to each other – and on Black Friday, those somethings are for sale.

But alas, all was not lost! Sometimes the salespeople, customers, and I weren't so fully subsumed in our roles that we forgot that we're persons.

Which brings me to the point of this letter. I need help figuring out if any good came from this one day of trying to fully concentrate on being nice to people. Even after all this time I still can't quite decide, so, would you mind thinking it over with me? Okay, well, here goes…I'll tell you about the fine folks I met and you can take your time writing back with your world thoughts.

…First, I ran into two half-clothed YA men standing in front of Abercrombie & Fitch. They were offering photo-ops for the attracted passersby. I wanted to say hello, so I got in the photo line and waited my turn. One of the young men told me he liked my glasses as the photo snapped. I thanked him and the other person and wished them a good day.

Inside Bath and Body Works, a few smiles were exchanged along with descriptions of coupons and scents to check out.

Next, I wandered into Build-A-Bear. It was weirdly quiet as I moseyed through the vast variety of stuffed-bear accessories. A woman asked if I needed help in a mandatory fashion, and I didn't, so instead I asked how her day was going, and she responded by telling me that they "weren't giving away free TVs." I asked if she enjoyed her Thanksgiving, and she told me it was very nice. She said if I needed any help to let her know.

(At this point, I made a note in my book that it was very hard to connect with people without buying things. Was I the Milk Carton in Blur's "Coffee and TV" music video?)

I kept my chin up as I walked to JCPenney. A man handed me a pamphlet at the entrance saying, "I have this for you." I said, "You made this *just for me*?" He laughed and then we both trailed off our chuckles as we continued on our respective paths. Further into the department store, a girl with large glasses smiled at me and I smiled back.

At Delia's, I was informed of a jeans sale going on. I only wear purple leggings, so I

thanked her for the info and asked how long she'd been working. She told me since 6 am, but that a few of the salespeople had been there since midnight. I made an empathetic icky face and told her I felt their pain, because of the many times I had to get up at 4:30 am to work at a coffee shop. She summed it up for both of us saying, "Early shifts are totally not worth it."

Feeling a bit overwhelmed and lost in thought, I stopped into Lord & Taylor and took a seat near a dressing room to reflect on my day thus far. Before I could consider all the implications of my previous conversations and smiles and non-smiles and how are yous, an old gentleman took the chair next to me. He told me how much he liked my hat. He too was wearing a stellar head covering, so we talked hats for a few. He mentioned that his wife was shopping around somewhere in the vicinity. The beautiful weather came up and transitioned our conversation to the Boston Christmas Tree. I told him I hadn't seen it yet, and he assured me it was spectacular (since then, I did get a chance to see the tree on a skating trip with my students, and he was absolutely right). He saw his wife approaching and got up to meet her while wishing me a great day.

At the MAC store, two ladies pointed me in the direction of the eye shadows "to go with my colorful ensemble." One of the women had sleeve-length tattoos, and I asked her about them. She told me her boyfriend is a tattoo artist on the North Shore, which is how she got the awful accent. I thought she sounded cool and specific, so I told her to consider rethinking that adjective.

On my way out, I ran into a man wearing a suit standing outside a watch store. We talked about the craziness of the day. He mentioned that not many people were stopping in, so he was taking a break to see where the droves of people were going. The conversation turned to advertising and he said, "People only shop at the few stores that advertise the most."

After looking around Betsey Johnson for a few minutes, I chitchatted with a fashion designer who also went to art school in the area. She had recently made a print of a banana for class that her teacher disliked, but she wasn't worried because designing clothes was her true jam. We exchanged information as she encouraged me to scope out her online shop.

My pace was slow through the mall, as I tried to look around at the people moving from store to store. I sat down at one of those mid-mall resting stops, but relinquished my seat quickly to a family looking for a spot to sit. I thought about talking to them, but didn't, as I imagined interrupting them to be less-than-friendly and thus in opposition to my task.

Next, I found myself wandering into Neiman Marcus. My neon presence in this store was cause for a certain level of personal uncomfortableness, however, this concern quickly diminished as I started talking with the salespeople standing atop the glossy walkways. After collecting a perfume sample in between the cosmetics and jewelry counters, a man complimented me on my style and we talked back and forth about the importance of clothing and accessorizing. He mentioned that he has heart-shaped glasses, too, but only wears them for driving.

Bose presented me with the most difficult conversation, in that it was nearly impossible to talk without discussing the day's sales on speakers. I could tell that the gentleman

helping me was proud to be doing his job, so I listened intently to the different specifications for a variety of headphones. Toward the end of his descriptions, I asked him how he felt about Black Friday, and he revealed that it was his hardest workday of the year. I figured I knew why, but asked anyway, to which he replied that he works not one, but three retail jobs at The Natick Collection making it an unbelievably long day. I felt awful for feeling tired myself and sincerely wished him luck as I reminded him that the day was already more than halfway over. Would it have helped if I bought some headphones? I wondered.

Moving along, I noticed that the concentration of people near Teavana was exponentially higher than that of previous stores (probably because of its corner location). I looked around at the people scrambling to taste-test the free teas and walked up toward the lineless register. The cashier looked bored, so I asked him how he was doing. He laughed as if my question was sarcastic and said, "Red Bull. Lots and lots of Red Bull is required to make it through this day." I said that at least the store smelled really good and he agreed.

At Claire's the manager yelped and exclaimed that I was just like Where's Waldo. This made me happy that we both laughed as I told her to be on the lookout for me in the crowds.

In Nordstrom, a woman hanging up a fur coat smiled at me. We got to discussing all the food we ate at Thanksgiving. Looking back, I sort of wish we wrote up a collective menu right there on the spot, because I remember that what she ate sounded delicious.

At this point, I needed the bathroom break I had been putting off for hours. On my way into the restroom a little girl wearing a sequined tutu pointed at me, her parents smiled. It reminded me of the time I was carrying a ladybug umbrella and a little girl in a car driving past held out her same umbrella from the car's window.

The last stop of my Black Friday was Santa's makeshift North Pole. The line to get your photo taken was very long, so I had to wait about forty-five minutes to meet the man behind the suit. At first, the wait posed no bother as I thought it would give me time to meet some of the other folks in line. But, to my surprise it was frowned upon to be an adult person alone standing in line to be photographed with Santa. I guess the news has ruined us all. When it was finally my turn, there were camera/printer difficulties being resolved, giving me a lot of time to talk with the Santa man. Who knew he was from the South? We conversed about how long his workdays are, you know, to get presents made and pictures taken. I winked at him as I waved goodbye.

...So, that was that. Maybe it was because it was the day after Thanksgiving and all, but I was feeling pretty grateful to have talked to everyone I encountered. I'm not sure if this handful of exchanges made anyone's day less stressful or full of further smiles, but maybe that's not necessarily the point. Maybe, there's just something about thinking about people that made the day special. What do you think?

Looking forward to hearing back from you,

Alaina

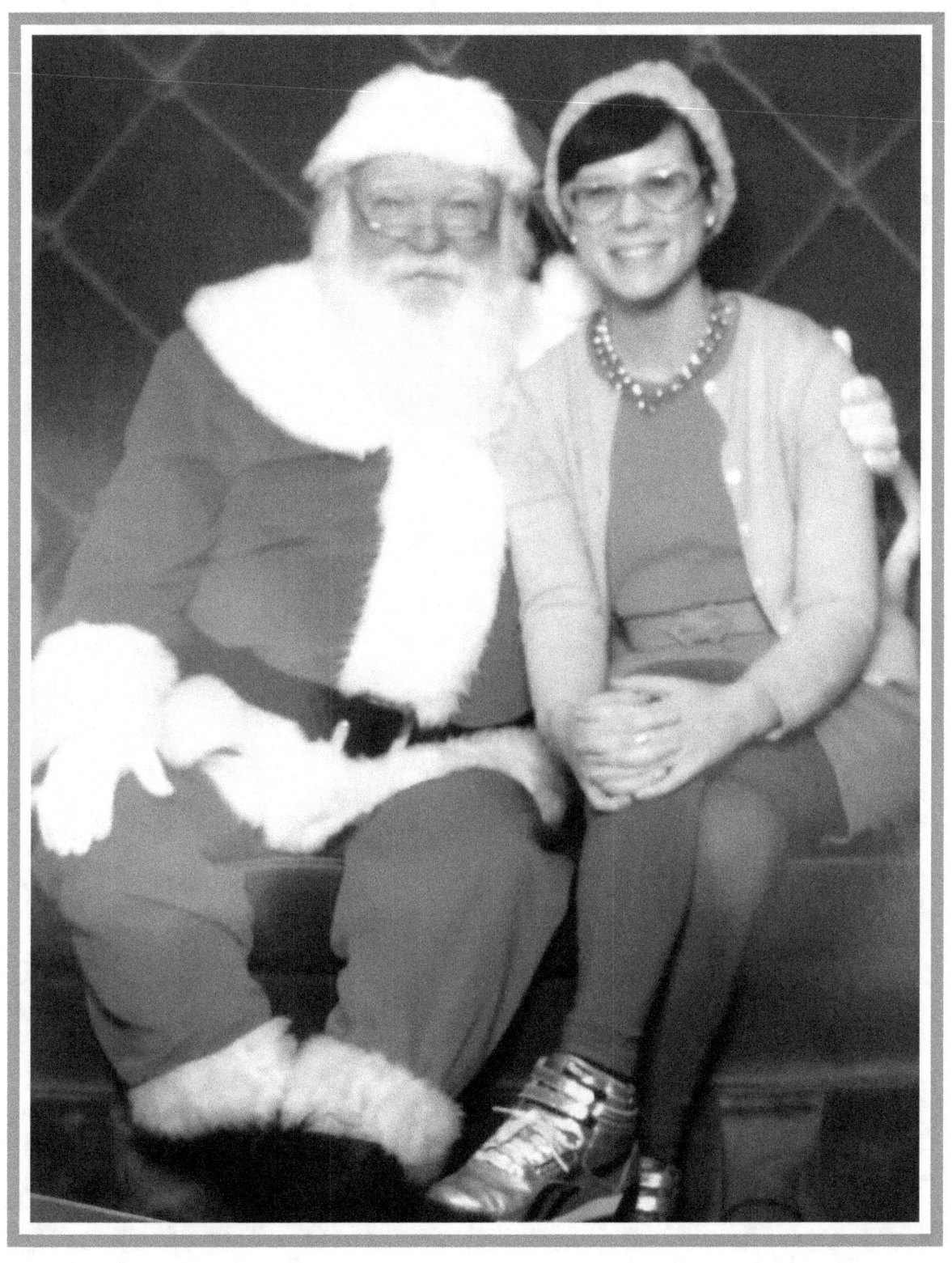

Blurry Santa with Blurry Alaina for Christmas 2011

Taylor McVay

On Friday, November 25th, after strolling around the Natick Collection mall, inserting anti-consumerist propaganda into the pockets of clothing, I decided it was time to make a purchase. I had been scouting various vendors for something that suited my style and seemed to fit within the parameters of fast fashion*. After careful and curious shop perusal, I decided on a button-up, collared shirt in a dark indigo cotton with reddish woven stripes. It was the only one of its kind in the Urban Outfitters sale section. I paid for my item, $29.99, thanked the cashier, and headed out the door.

I don't shop at Urban Outfitters. In fact, I rarely shop anywhere. When I visit stores, it is mainly to indulge in investigative browsing. This method of non-shopping as research is a somewhat recent development. My shift from shopper to non-shopper happened quickly; within a matter of weeks I had gone from recreational thrifter and vintage collector to a sort of retail ascetic. My position as such came as a result of two decisions. First, I needed to address my tendencies towards clutter by limiting my accumulation of non-necessities --specifically garments, but also furniture, accessories, and decor-- deemed aesthetically or conceptually valuable. My habit of marathon thrifting, combined with an eye for spotting vintage, unique, and high-value items amongst the racks resulted in many unplanned purchases. The second decision came about as a result of researching and contemplating the garment industry. The information I acquired produced in me a strong desire to abstain from participating in the consumer link of an incredibly problematic supply chain.

There are many reasons why I feel strongly about responsible consumption, especially in regards to fashion. In many ways, the fashion industry exemplifies the worst facets of the post-industrial world: exploitation of workers, deterioration of cultural traditions and cottage industries, and the defilement of our natural landscape. However, I will not deny the power of clothing as subjective voice. Garments are a cultural, emotional, and social language like no other. My reverence paired with intense repulsion created a need to break open the facade of the 'fashion machine' and get a better look at its machinations, from the factory floor to the runway to the resale store.

While working and training as a 'seamsperson', I have developed an awareness of the exceptionally high value of the garment worker. That is, the value that the garment worker represents in theory. The reality of the situation today is, more often that not, a mere echo of the condemnable conditions of yesteryear, but with better technology. Clothing construction requires skilled hands and intellects and, as a result, is one of the few manufacturing jobs that cannot be fully mechanized. However, the majority of consumers treat garments as they do any other disposable, mass manufactured product.

In our consumer consciousness, the people that create the clothing we purchase are removed from the equation. We see only the garment, not the amount of work that went into it. Many people do not even consider the labor that went into their clothing and to no fault of their own; the garment industry is not known for its transparency. This unconsciousness on the part of the public may also be due to the diminishing role that sewing plays in many people's daily lives.

Although I have my misgivings about the 'fashion machine', I do believe that there is unrealized liberating power in clothing. The most potent instances come in the form of artworks that liberate the artists or aid the artist in liberating others. Joseph Beuys' Felt Suit comes to mind for the former, Hélio Oiticica's Parangolés the latter. While our understanding of the value of clothing has diminish with its expanded availability, that surplus also grants us the situation in which one can begin to think about clothing-as-liberation instead of necessity.

This shirt was purchased with the intention to re-understand the labor that produced it. I took the time immediately after purchasing to disassemble the garment, handling the shirt with the spiritual motivations one might have evoked skinning and preparing an animal they had caught. After removing all pre-existing stitching, the garment was sewn back together entirely by hand over the course of a few days. This slow and reflective process attempts to make visible the labor involved in a particular garment. Through performing a garment's construction, we make an attempt to reconstruct a holistic relationship to a garment, to illustrate what a garment could be when one is given the opportunity to reckon with its conception.

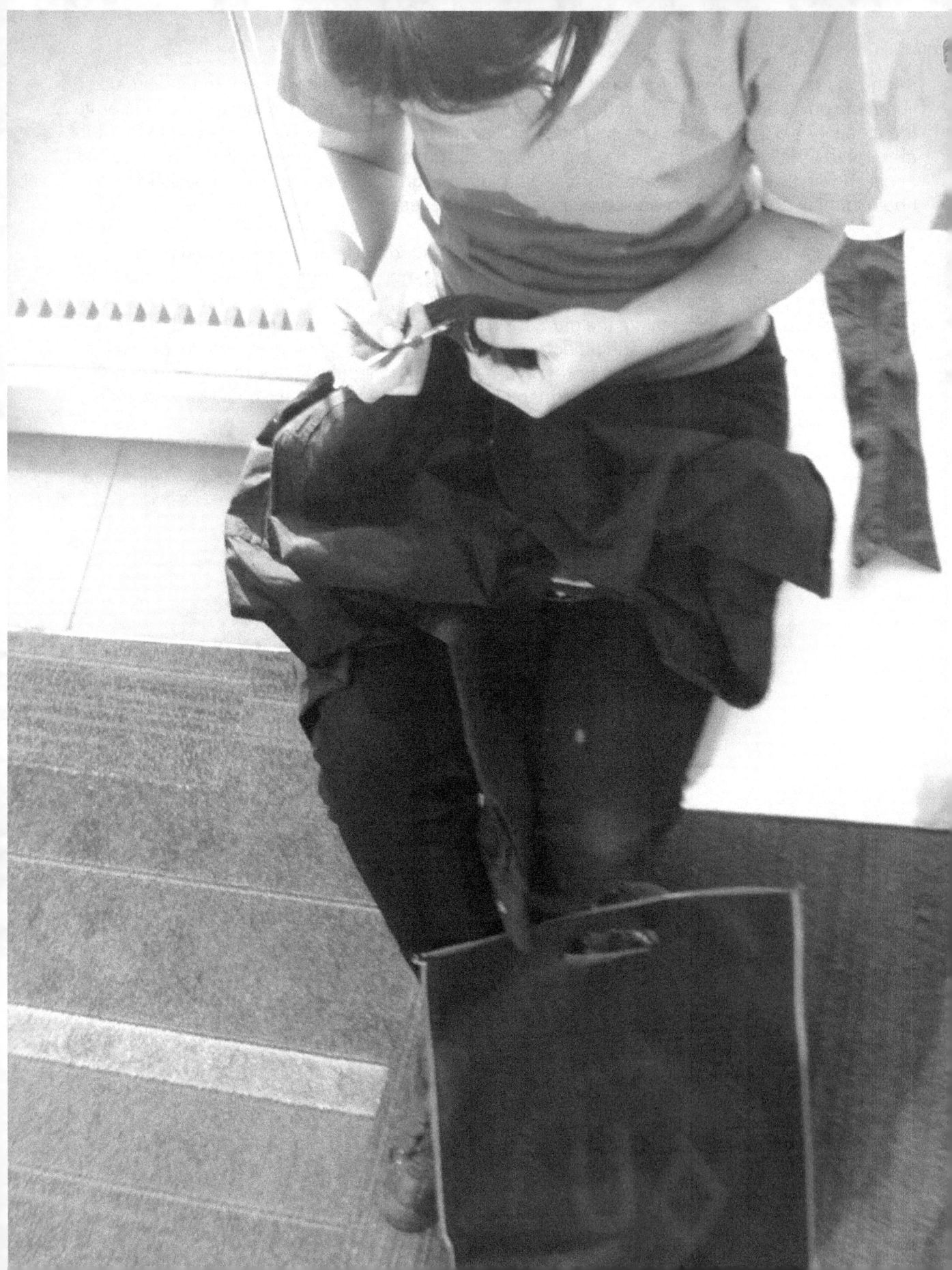

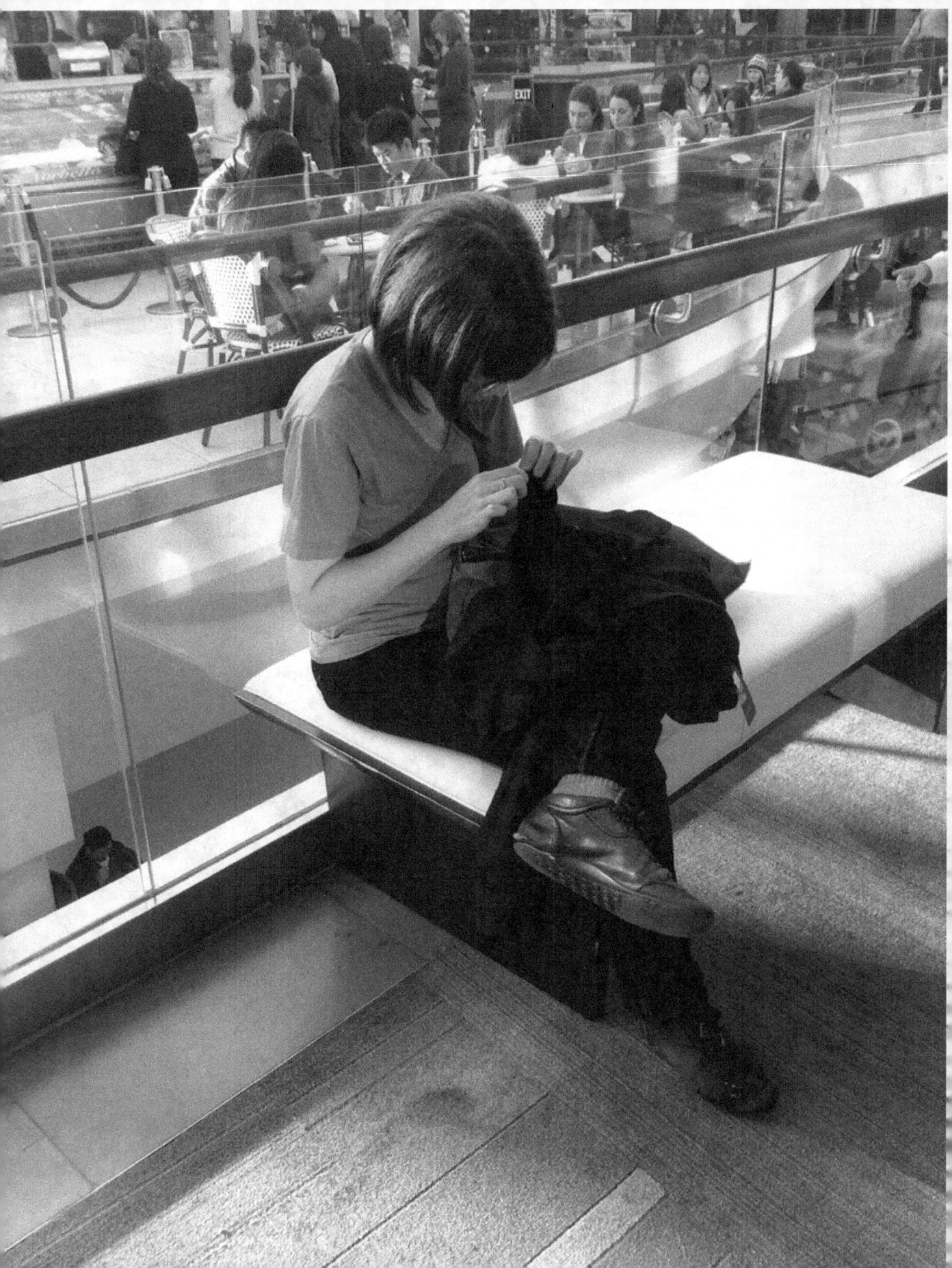

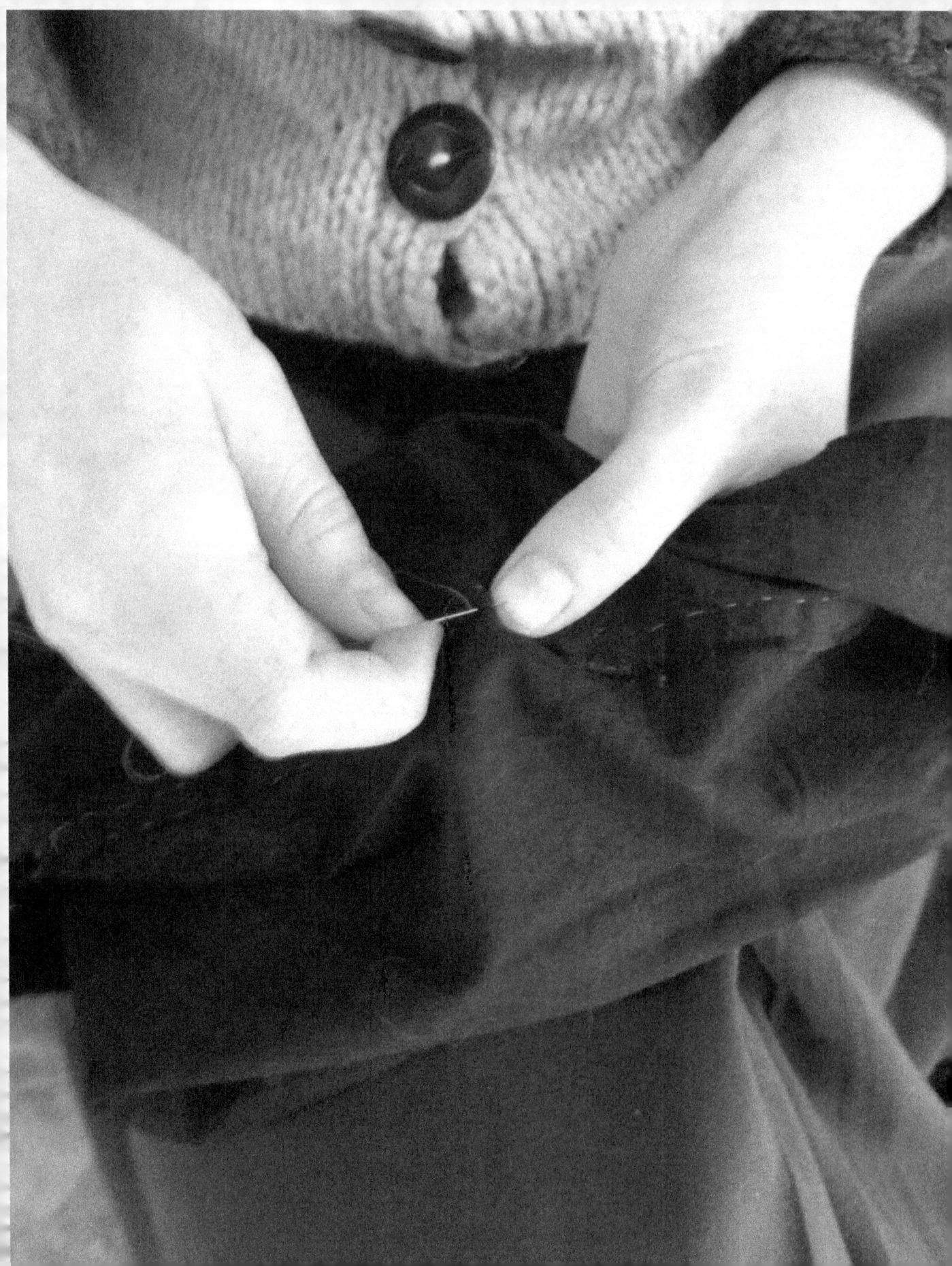

Our Gift to You:
20% Off Orders Over $100!
*Details

URBAN @UTFITTERS

Shopping Bag
Order Status Sign-In

Women's Men's Apartment Sale Gift Community [Search] GO

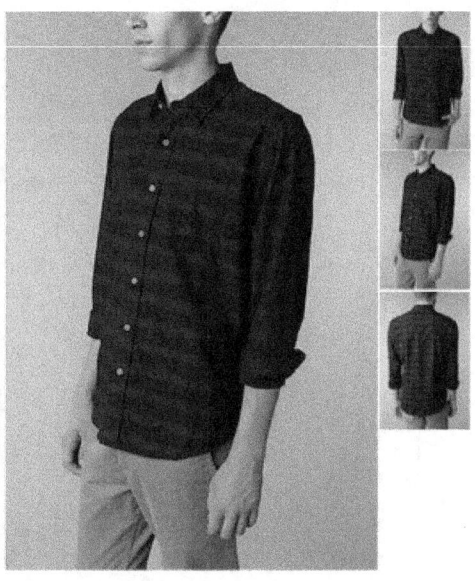

Koto Yarn-Dyed Indigo Dobby Dress Shirt
$64.00

Overall Rating
☆☆☆☆☆
Read Reviews (1) Write a review

COLORS:
■

SIZE: QUANTITY:
[Select Size ▼] [1 ▼]
📏 Size Chart Check Availability

Add to Bag 🛍

Free Returns!
& Free Shipping on all orders over $50

✓ Add to Wishlist
✉ Send to a Friend
🐦 Tweet 0
👍 Like 1

More Ideas

Reviews | **Product Details** | **Ask & Answer** | **Social**

SKU #21366117

Overview:
* Button-down shirt in allover dobby stripes from Koto
* Constructed in woven yarn-dyed cotton
* Pouch pocket at the chest
* Curved shirt hem
* Logo pattern tag at the side
* 29"l from shoulder to hem
* UO Exclusive

Content & Care:
* Cotton
* Machine wash
* Imported

TAGS [2] [ADD YOUR OWN TAG]
BE THE FIRST TO TAG THIS ITEM!

Anthony Montuori

The Natick *CREATIVE Collection

Question:

The Natick mall, like any other, is an ample site for consumption. How does it fare as a platform for creativity; for engagement without purchase?

Answer:

The subsequent documentation highlights my encounters in the mall on this topic. From the sculptural forms conceived out of the gifted sheets of paper and displayed on the Mall's existing pedestals. To digital tablets, gaming devices and cameras dotting the landscape and calling out for alternative (or perhaps normative?) interpretative usage. Persona and identity was constructed that day. With the final act of performative utility carried out in solitude on a porcelain throne. My holy pilgrimage thus chronicled.

Result:

Plate 1 – The Demand
Plate 2 – The Flight
Plate 3 – The Form
Plate 4 – The Enthusiasm
Plate 5 – The Refined
Plate 6 – The Progenitor
Plate 7 – The Persona
Plate 8 – The Why/The How
Plate 9 – The Shit

*creative

NATICK MALL

*what's your favorite label?

Free People
Anthropologie
Urban Outfitters
Hollister Co.

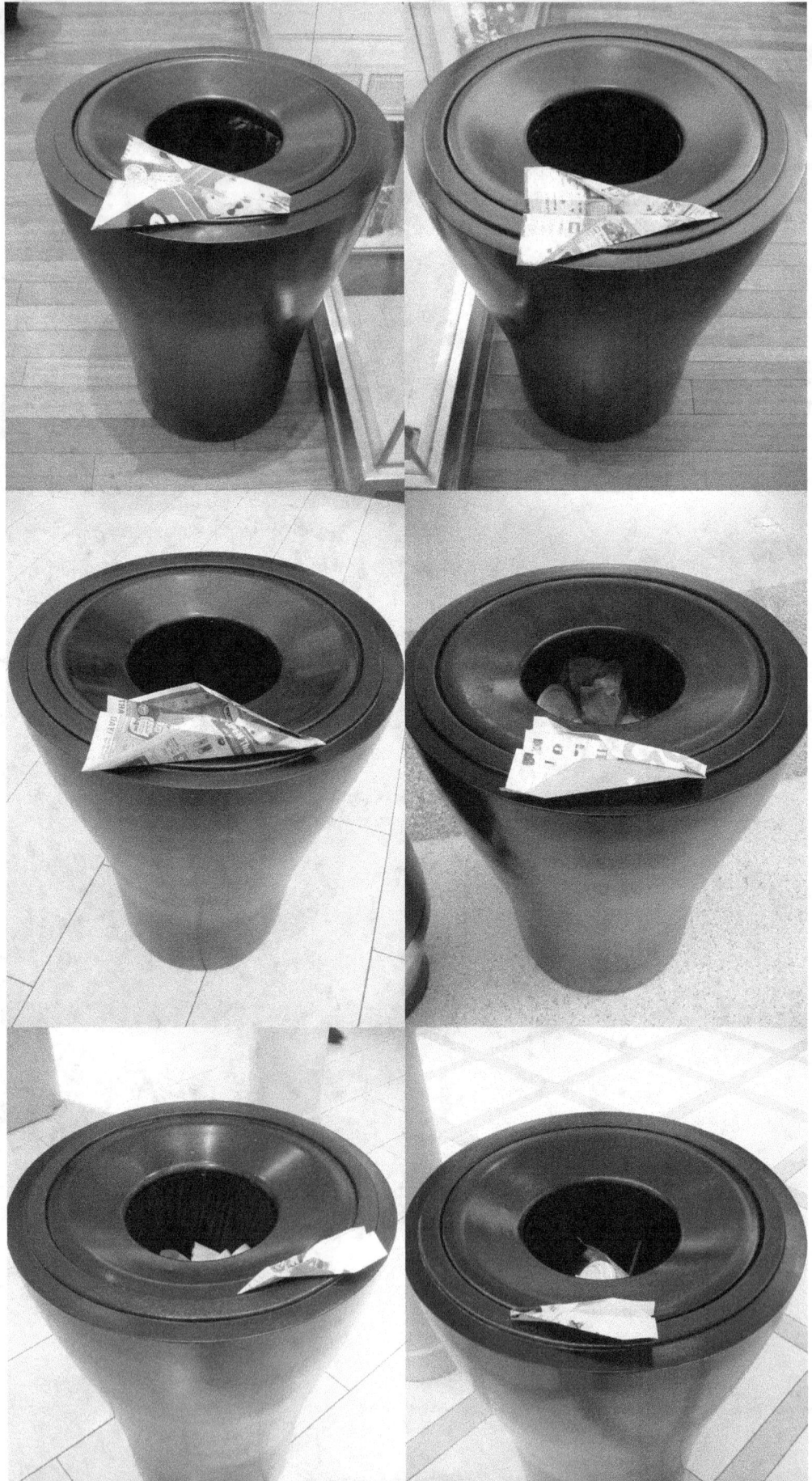

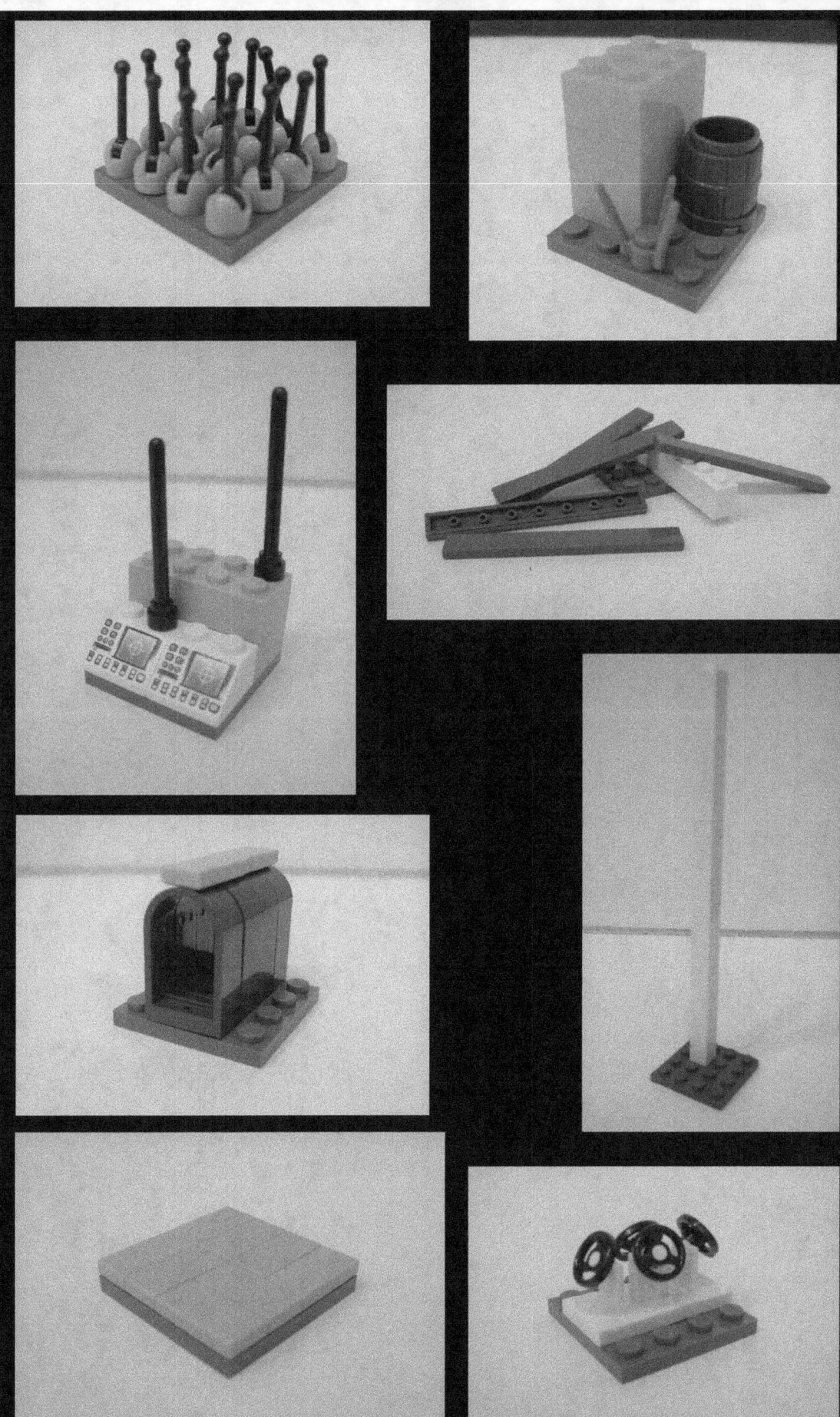

Miles Pflantz with Laura Bluher and Dave Randall

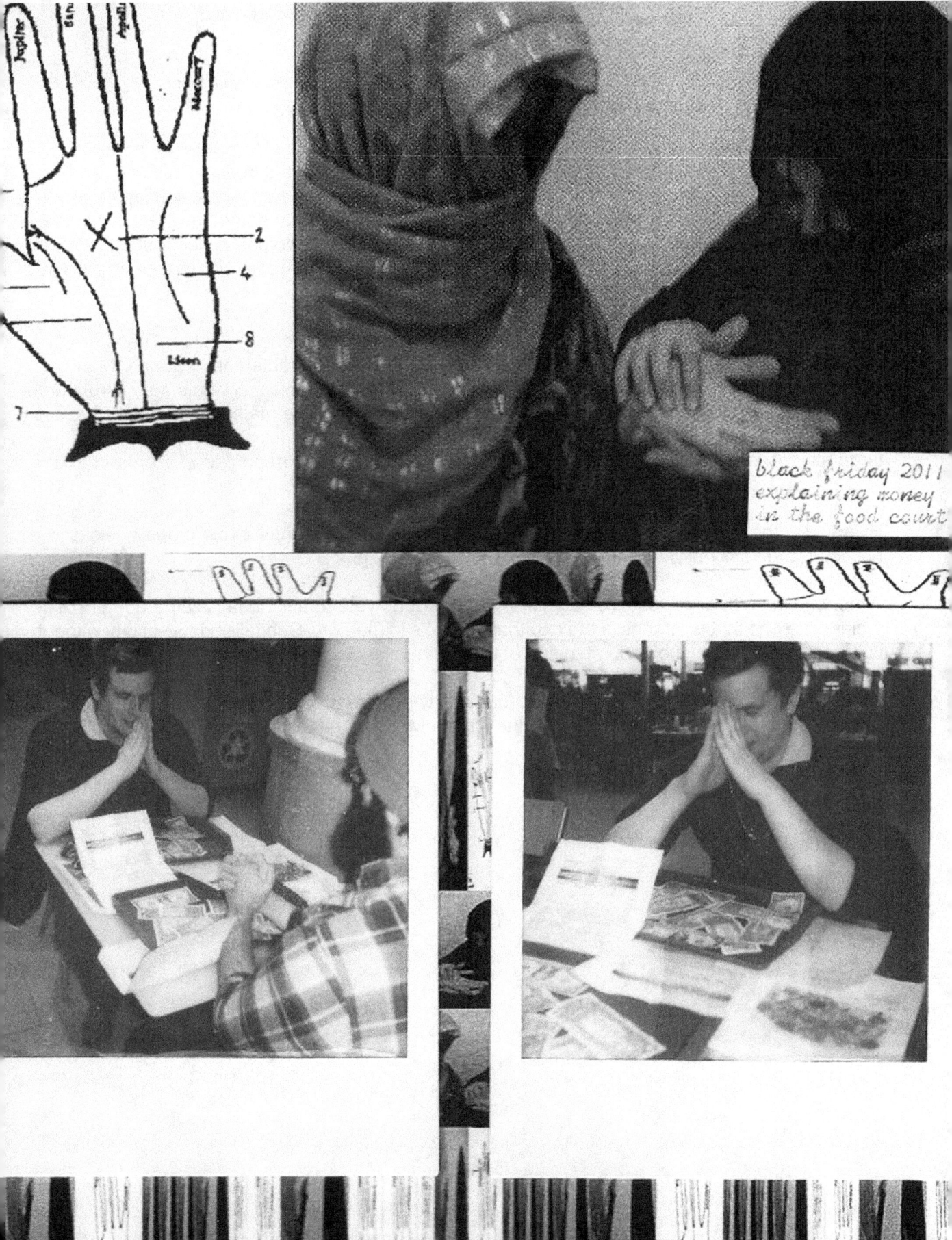

black friday 2011
explaining money
in the food court

What needs to be explained? We know we're being cheated. And we'll probably always be cheated.

But it is best to make what seems natural feel strange - to make it clear that it is the result of some very strange goings-on. The most brutal savageries are inherited from logistics devised out of stupidity. No one will listen. Everyone will avoid eye contact. The history of American money is wrought with lunacy. In Jamestown, tobacco was used as money for some time. So, of course, everyone only grew tobacco. Could you imagine a place where everyone is rich, but there is no food to eat? The wet dream of neo-liberalism. Let them smoke cigarettes, I suppose. And if you want to eat, call a creditor.

Money is the medium of exchange. All values can be reduced to monetary value. These are the two use values Marx discovered in money. Things go haywire. A table comes to life. Man can no longer recognize himself in the value he created; rather, that object controls man. Profit determines law, governs interaction, and plays possum with labor. The material conditions that set the stage for secular democracy dragged God to death, although kicking and screaming in the large expanses of America that never developed. Socialism is the preparation for an end to the alienating effect of money.

Eventually, the lawmakers in Jamestown legislated that farmers must grow crops besides tobacco. We are still oblivious to this lesson, and scarcity reigns.

A teenage girl with a McDonald's bag asks "Are you done yet?" Black Friday is a parade of spectacles. The one that is strange is the one that commits to memory. Capitalism is a society without culture - culture being the understanding of the social relations that compose a society.

We explained money through a simultaneous reading of texts on the subject. Sources ranged from Lenin to a pamphlet for children by the Chase Manhattan Money Museum. Onward Black Friday culture!

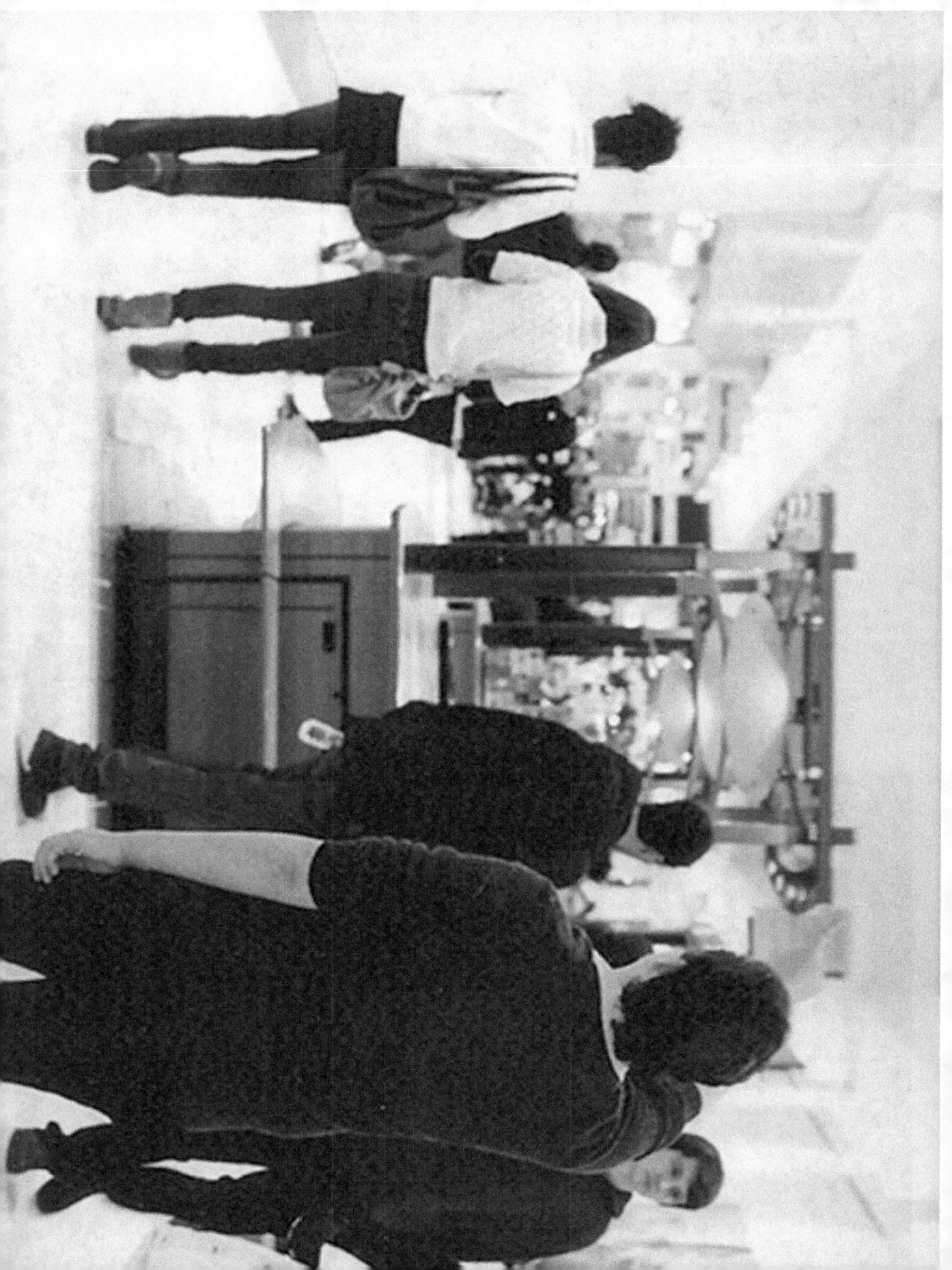

The sun is the center of all life. All life is connected in the sun. We share in the sun by consuming those that consume the sun. If life has a law, it is the transfer of immutable energy. So, the sun resides in meat and murder. And organisms make small evolutionary steps to become the sun. Through the practice of history, man becomes the sun, the creator of all energy, our own source. The stars were dead the second we could no longer see ourselves in the constellations and our history is a long reckoning of this truth. Through will, in accord with will, transform. No, destiny, we do not need the sun any longer. Our will is to overcome history and become the sun. If man could swallow the sun, comfort would only be found in the infernal eroticism of disease and night.

Into the night go the fires, into the fires we hesitate. Always beholding never touching. The screen is not a surface. It is a barrier. As is the sky.

What does fire know of hesitation? The great lengths that fire spans to prove it knows nothing. Fire names all of the organisms that spread across the earth - because any that remain in its path become fire. Through the fire some will pass, away from the fire others will roam. Stillness though is the possession of fire and all stillness possesses is waiting for fire. Waiting is pursuit through perverted means. Where come the fire?

One second work day, three second meals - shove it.

In a mall, the gesture of pointing is charged with significance. Non-verbal directive. Everyone who works at a mall must point at some point; everyone who wants something in a mall points at what they want.

The action was to point at the sun from inside the mall until interrupted. It ended with a request to do it naked. Had we but world enough, and time...

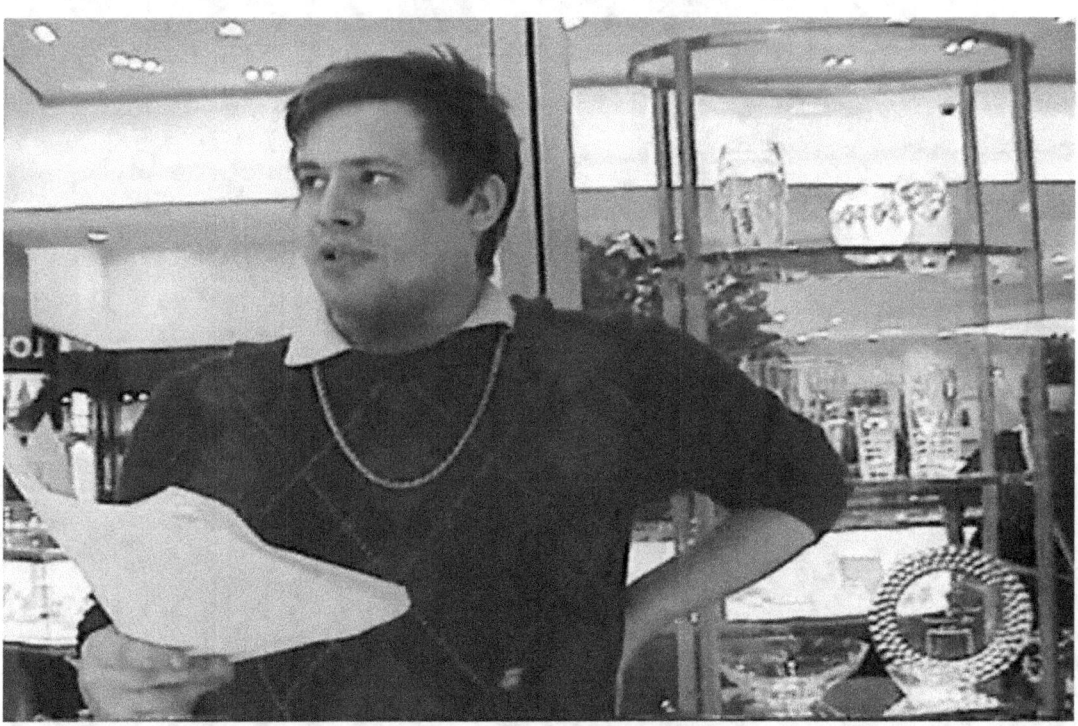

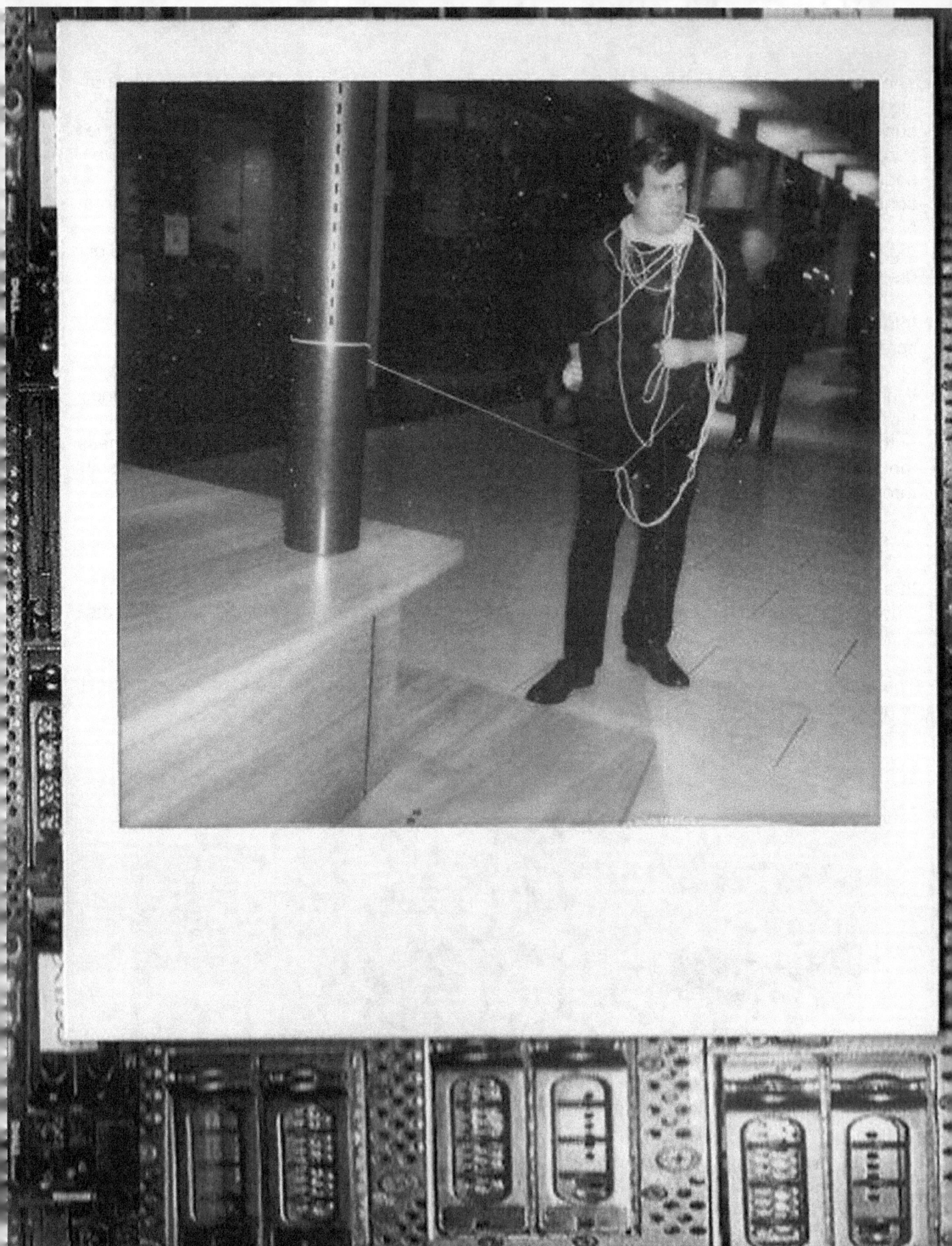

black friday 2011
tied to the only empty kiosk
ended by security

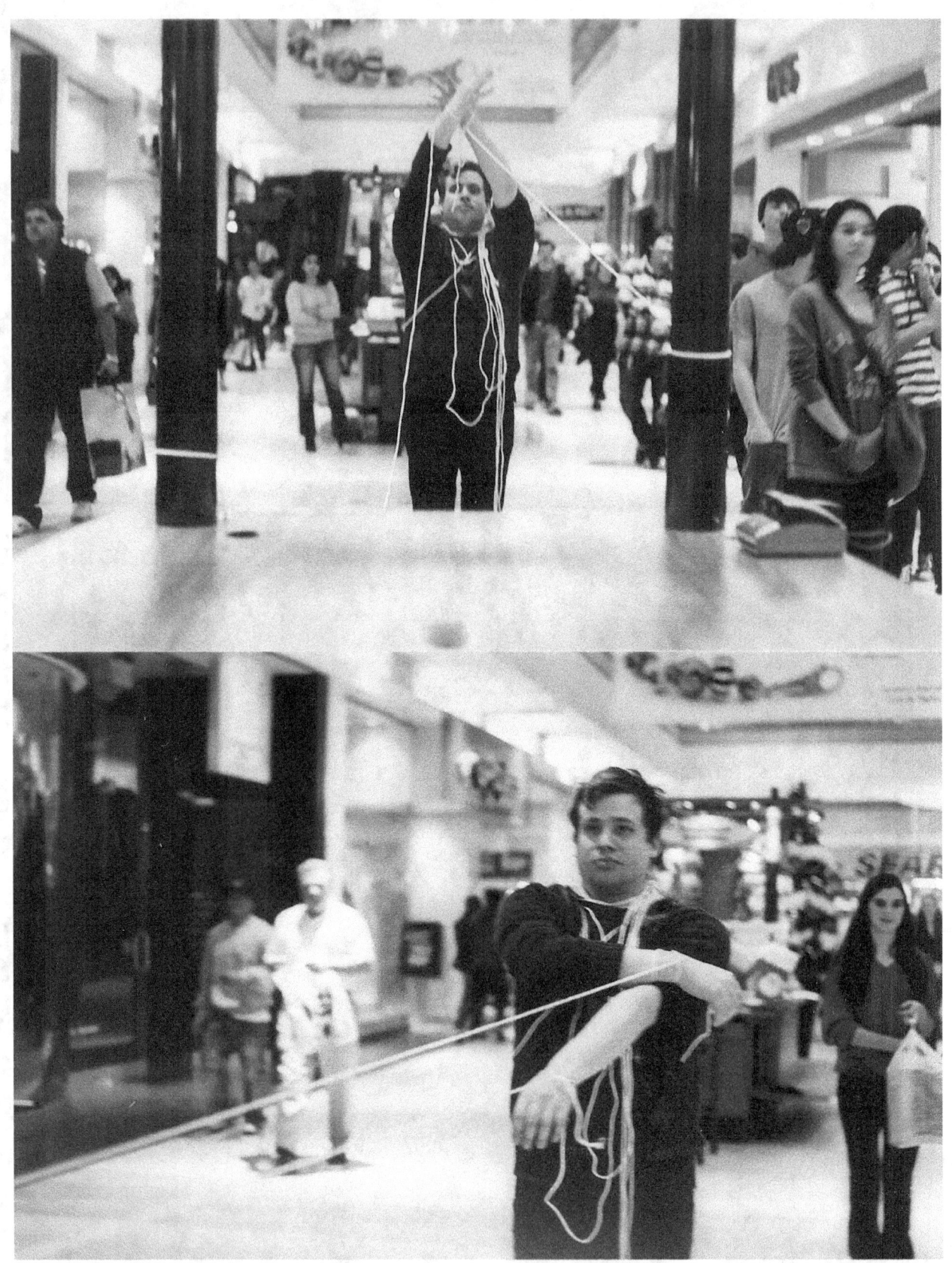

Attempt to move the kiosk from the mall

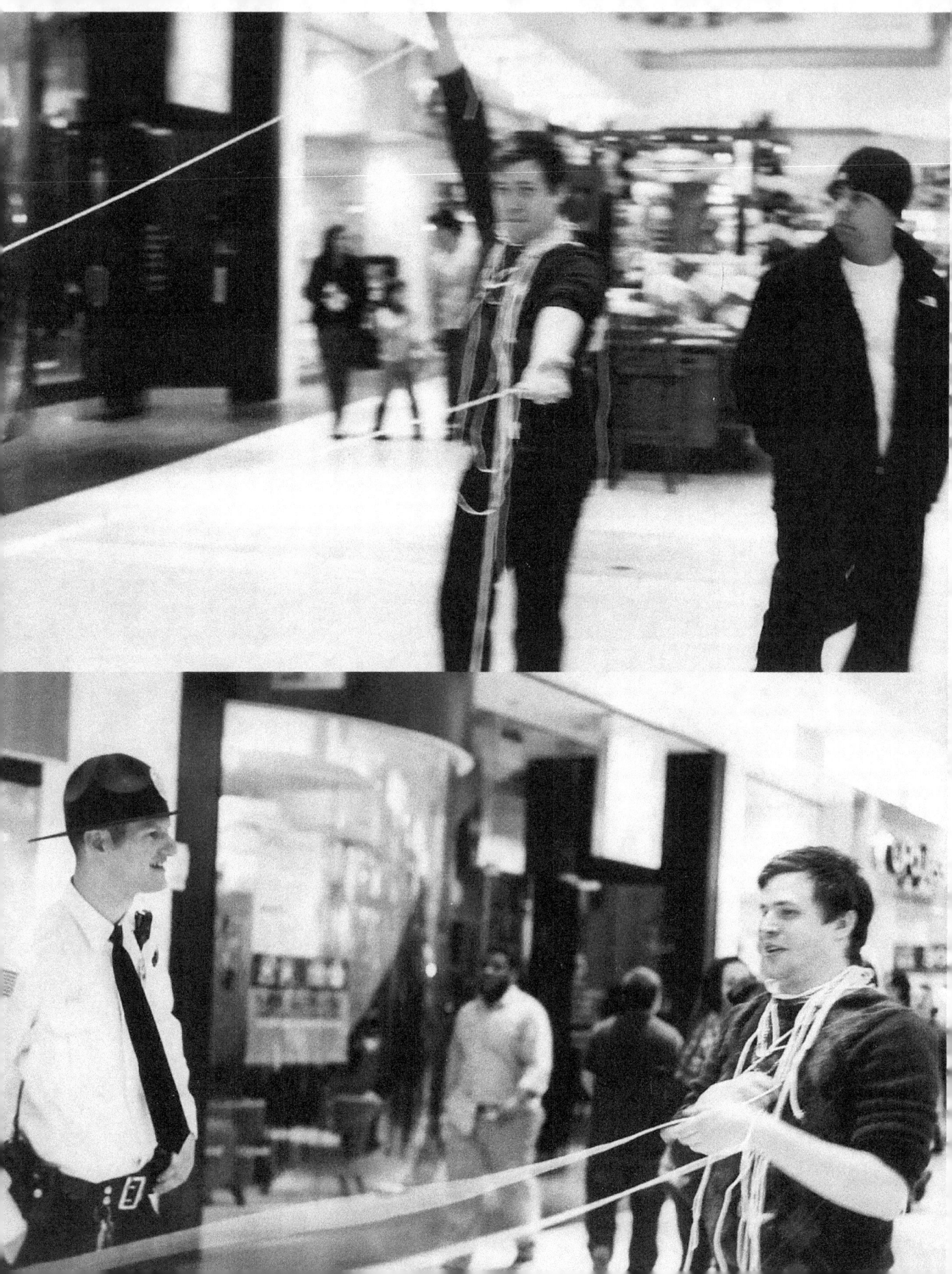

Nina Prader

Black Friday:

Lugner City as Natick Collection

by Ninum:
correspondent
myth-maker
serious pretender

enter Lugner City as tourist
export as tourguide
does not assume to know the way

Austrian Analogy:

In the current global economic crisis, synchrony is the shared element between Vienna and Boston. Black Friday has become like a national holiday in the States. This action in the Lugner City took place out of solidarity for the group performative action at the Natick Collection mall in Massachusetts on November 26th 2011.
The motive was to analyze, explore, and juxtapose the myths and syntax of the "Viennese mall" in a mode of literary qualitative observation.

Itinerary is to Shopping List
1. Walk it
2. Document it
3. Sticker it:
4 End in the center and twirl.
5. Mozart Kugeln special discount

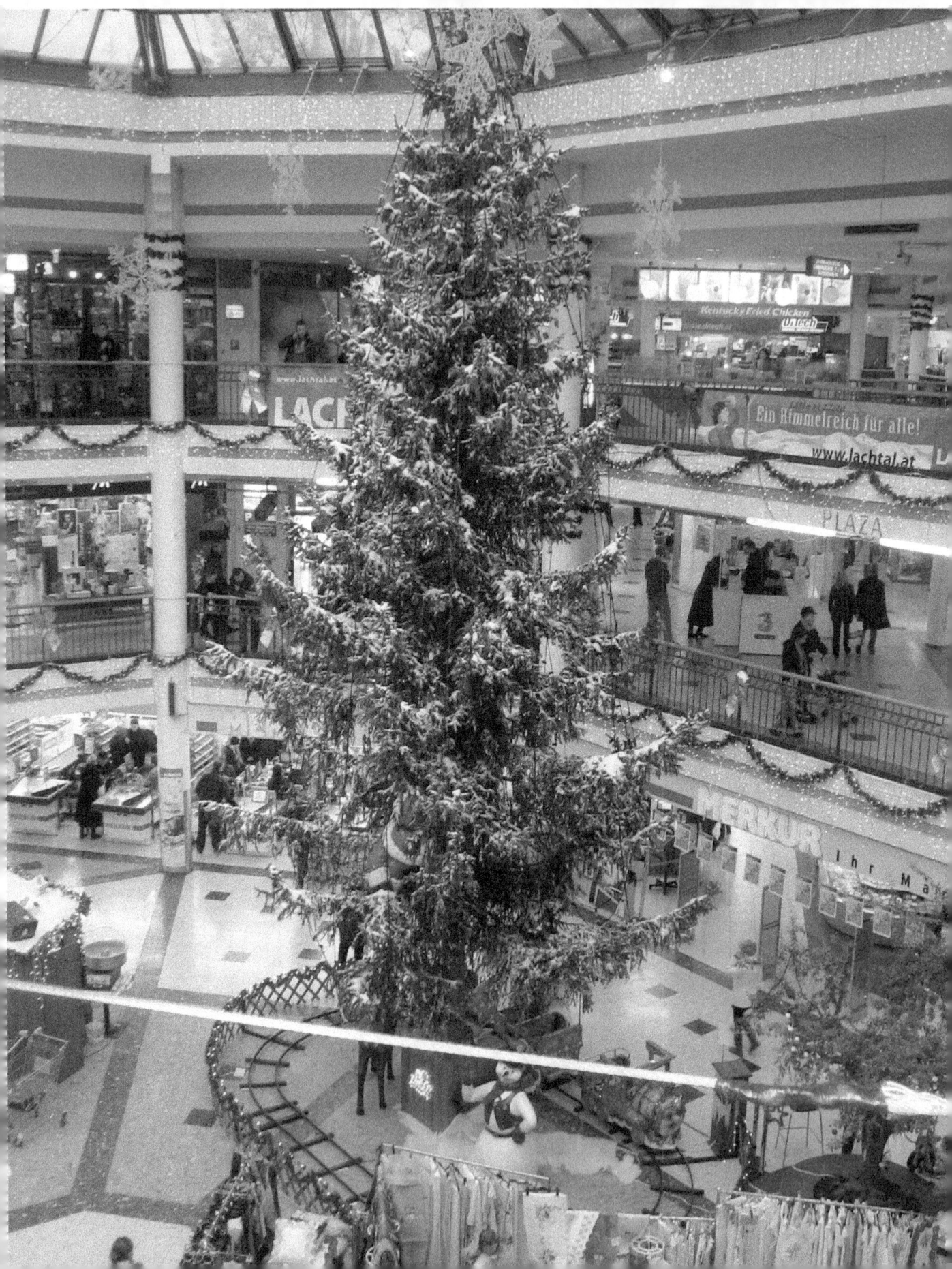

Architecture:

The Lugner City has three stories and is shaped like an octagon. In the center there is an open space reminiscent of a forum found in ancient Greece. At the fore, is a stage for products to be advertised from. The space as a whole is decorated solely with Christmas regalia, a giant Christmas tree looms to the third floor around which a children's locomotive choo choos. In this center, there is a little market made out of small wooden huts, meant to imitate a traditional market set-up; in contrast to the surrounding modern marketplace structure of the mall.

This shopping center seems to model itself after the function of a park. An open space that would connote the potential for a space of culture and discourse. However, the open air space of a park symbolically promises democracy. At Lugner, you must wrestle with the potential of being enticed to spend money. Everyone desires. The mall promises the quenching of desire, only to rebound, and desire again. Nowadays shopping, and how you shop is often equated as a new form of voting. What you buy is your individual choice, and your choice is determined by your values and ethics. No pressure... Consumerist culture would have you believe that this is a form of democracy, it is an open forum as long as you have the means: money.

Nun in Libro

But rather than political, the generally propagated consumer relation to the commodity seems to connote religious undertones. For the "need to buy things" functions like a higher power under which the consumer subjugates themselves under a false sense of individualism. As if an individual is marked only by the accumulation of a set of things.

Syntax:

The entire article may be viewed as a variation on that much misused remark; or as a monstrous "museum" constructed out of multi-faceted surfaces that refer, not to one subject but to many subjects within a single building of words --a brick= a word, a sentence= a room, a paragraph= a floor of rooms, etc. Or language becomes an infinite museum, whose center is everywhere and whose limits are nowhere.
-Rober Smithson
A Museum of Language in the Vicinity of Art

The Lugner City as a literary text.
Store names/signs function as words and as parts in their placement/relationship to other names/signs. Strung together they form the architecture as a paragraph.
The architecture is circular with 8 corners(= octagon) and has an underlying cyclical, tiered logic: the consumer/reader is forced to walk in circles on multiple levels, tricked to revisit potential shops, and thus, possibly revisit an unarticulated want for a thing.

The market place is like a mirror. The products sold act as material symptoms of our current times and the language of the storefronts seem to function as metaphor to current macro power structures and cultural conflicts particular to Austria and in relation to the United States.
.
For example, upon entering Lugner City the Kebab/Pizza place is parallel to the gaudy Jewelry place, selling diamonds shaped like Edelweiss. The jewelry as an item seems to symbolically demonstrate Austria's wish to cling to an elite conception of an originary Austria, whereas the Kebab place juxtaposes the reality of a multi-cultural marketplace.

The Categories and Values of the Lugner City:

The pace of the Lugner city seems to soothingly ensure your leisure.
No need to shop till you drop. Take your time, and stroll.

 1. Food
 2. Appearance
 3. Leisure and Dirty Thoughts
 4. American Imports
 5. Democratics and Organics

Food:

Of all consumer items available food ranks the highest. The concept of a food court does not exist. Literally, every floor is a fragmented food court, with grocery stores (Merkur for those with larger wallets and the Penny Mart for those keeping a budget)and cafes.
It is only possible to sit if you intend to purchase a drink or food.

Stores dedicated to staple products:
Anker: Bread
Schokothek: Chocolate

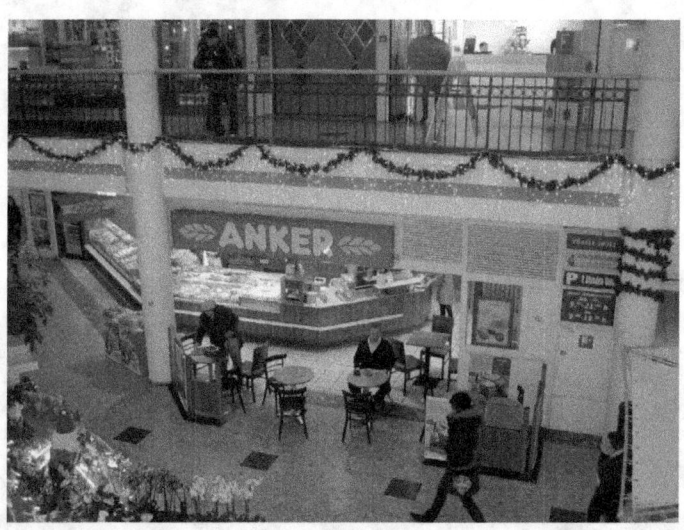

Appearance:

The female beauty aesthetic that is sold at Lugner City rests on hyper western ideals of beauty. Stores relating to blonde hair extensions, nails, clothes, and shoes can all be found in the vicinity of one another. The employees in the shops must wear such mainstreamed conceptions of beauty on their person. Though the female employee at the Miss Moda sports a platinum blonde bob, her black skin-tight shirt with an open back reveals the telling five eyes of Ala tatooed down her bronze spine.

Leisure and Dirty Thoughts:

In one corner there seems to be a subliminal sexual syntax to the logic of the Lugner. Ironically, the sausage store (Wurst:Wiener) is situated right next to Penti, a store that sells women's panty hose and showcases fragmented legs in its storefront. Across from the sausage store and the panty-hose is a lock smith store that sells keys. Munch on a sausage, whilst salivating over a pair of prosthetic legs donning fishnets and buy a key to unlock a door to a lady's heart.
(Image)

In contrast, to the Puritan Natick Collection the Lugner City boasts gambling opportunities as well as a sex shop -that beckons with mannequins dressed in Santa's lingerie-'tis the season across from a telephone store.

American Imports: with Austrian Interpretations

Burgerking: stainless steel countertops and mosaic bathrooms

Claires: Adapt to all American girl ideals and dress her pink.

Corn in a cup: The logo is under construction.

Cinnabon: sells the American pastry known as the cupcake, however, its manufacturing demonstrates that this version of the cupcake is based on a Viennese interpretation.

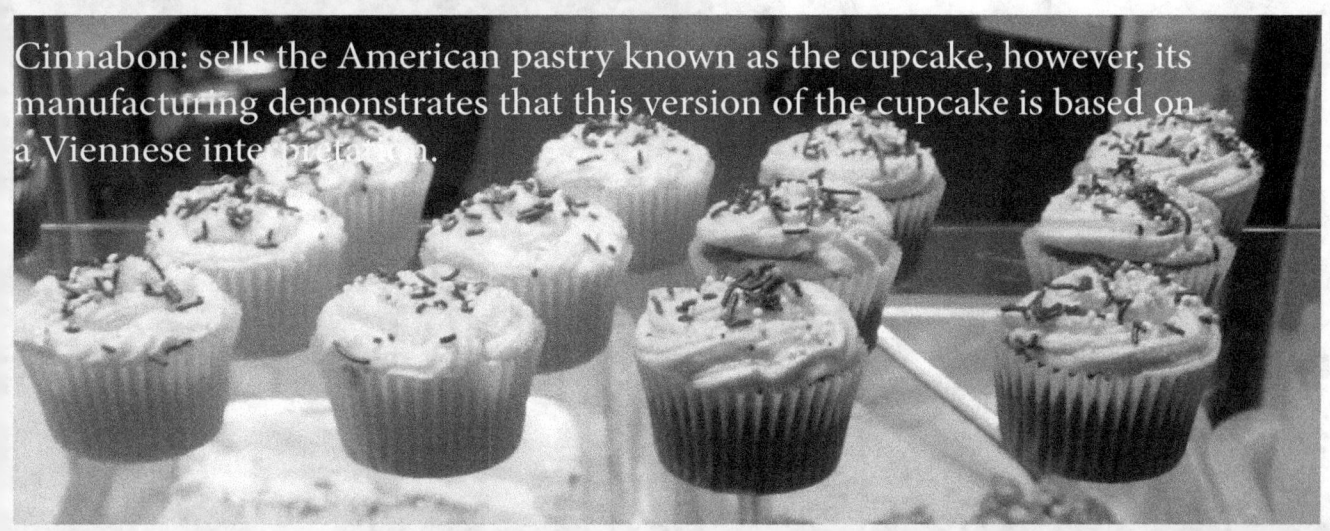

Cigarettes:

Ironically, the children's toy shop next to the Tabak/Tabacco shop. Mr. Lugner the owner and founder of the mall thinks that smoker's are nice, that is why there is a smoker's lounge built into the logic of the system.

Democratics and Organics:

The Lugner City with its abundance in natural produce also has a flower shop and pet store with animals at reasonable prices. Across from the Libro, a book, pen, and paper store, children have the opportunity to learn how to bake christmas cookies in one of the wooden huts located in the center. Furthermore, there is a printshop.

*English is the predominantly used language to advertise a product. The slogan is written in English and the elucidation of the slogan is written in German.

Closing thoughts:

This is an art-action as pacified, aesthetic "intervention". When making an analogy, you take one term and compare it to another. Antagonism creates myths of opposite poles. In this comparison, there is no hierarchy of contrast. One side of a term like "mall" of a particular place can demonstrates negative and/or positive structures in itself, however, in juxtaposition to another term it can counteract.
Art that materializes as material thing cannot evade its subordination to power structures of market systems, it can only butt heads, or learn from oneanother. The occupation of space for art's sake can only make physical that gap inbetween reality and myth.

Chris Soldt

It has become commonplace in the realm of online social media sites to indulge one's curiosity in other people by investigating the pages and profiles of those that they know and, perhaps, will soon know. Sites such as Facebook, Twitter, Foursquare, Google+ and Linkedin succeed because their design and functionality mimic (as well as simplify, why ask someone about another person when you are a few clicks away from acquiring the information yourself?) aspects of face to face interaction and they allow others to expand their social circles and feel a greater sense of connectivity (to people as well as information). Would you like to know what a friend is doing this evening? You can check their status to see if they posted their plans or perhaps they have updated their current location and it will appear publicly in your news feed.

The check-in function of Facebook allows the user to enter the name of a location; be it a restaurant, bar, or store, and they can tag friends who have joined them. The owner of said business has most likely created a page for their business in order to post updates about sales or specials. This page is automatically linked to the post with the hope that you will click on the link and visit their page. Facebook's location function doesn't necessarily rely upon using GPS technology, though it allows the user to search for locations in their vicinity. Foursquare functions in a very similar fashion to the check-in feature on Facebook, except that is set up like game. The point of the service is to allow users to keep up with their friends current whereabouts as they accumulate points and status (in the form of themed merit badges, e.g. Local, Crunke, or Overshare) while at the same time online advertisers are able to access information about your preferences and behavior so that you can be the subject of more effective marketing. A by-product of these features is that you can also see the other people who are also currently in the same location. You can see their photos, previous check-ins, point tally, and badges. Part of the fun of this phenomenon is that you can make a game of it, scouring the room with the hope of identifying the other users in the area.

Rules of a proposed game / Proposal for new app:

Log into your preferred social media site.

Check in to your current location.

Verify if there are other people checked into same location.
Click on tab that connects to a page with a map of the site from Google Earth.

You should be able to properly survey the room and mark where the other users location (10 points and the badge for casing the establishment).

You can now identify and evaluate their clothing, the book that they are reading or the shape and make of their glasses. (5 points for each connection that you make to external website).

The last phase of the game involves the game of mental chicken, where you deliberate whether or not you want to approach any of the other users in an effort to make contact IRL (in real life). (Number of Points varies on the duration of interaction and whether you become friends within the game and on other social media sites further connecting the two of you).

I played a more involved version of the scouring game in a very large location on a very busy day (see image 1). I toed the line between the cyber-flaneur and private investigator (I liked to think of myself more like Philip Marlowe rather than Sam Spade or Mike Hammer, though upon reflection I was far more similar to Jonathan Ames, see image 2).

Opening Paragraph of a Detective story of the events.

When you spend enough time doing the wrong things in a given set of circumstances, it is much easier to spot clear signs of trouble. For Riley it was a matter of accepting too many jobs from the wrong sorts of people. It's the sort of job that invites the wrong sort of people. They flock to you like distant, obscure relatives with the promise of an open bar or a fat inheritance. Then again good luck finding a job where you only confer with the right sort of people, after a while you realize that there is no right sort of people and we're all just folks.

I walked around the location for hours while wearing a zoom recorder with a lavaliere microphone to record my activity (which added to the procedural delusion since I was wired like an undercover cop). I mention the flaneur since I was in a commercial space where I had no intention of making any purchases, besides my lunch (vegetable lo-mein and pork combination plate) and the 2 cups of coffee from Barney's, and attempting to maintain emotional detachment for the purposes of intellectual investigation. The descriptor is also apt because of my socioeconomic status (a white male from a relatively affluent background with enough free time to wander around a mall for 8 hours). The mall was flooded with shoppers fresh from Thanksgiving and on the second day of a four-day weekend. The shops and walkways were flooded with resolute bargain hunters. I weaved in and out of the unsuspecting throng attempting to locate fellow Foursquare users. Most of the search was fruitless, it was difficult to fixate on any one person as they negotiated their way through the horde and I was attempting to do the same. As this was part of a group performance exercise, I kept myself amused when I happened upon one of my fellow performers and monitored their activity. I observed them from a distance as they browsed through Brookstone or the Lego Store. Difficulties arose when I attempted to observe from outside the store since there were few places where I could stand still because the arteries were choked with people. I was like a large piece of plaque obstructing the flow of the mall's oxygenated blood.

While I am tall I am relatively nondescript, so even though I was talking to myself for the majority of the day and constantly monitoring my phone, it simply appeared as though I was in the middle of a very long phone call. There were two main problems with my investigation. One, while there were thousands of people coming in and out of the mall there were never more than 30 people checked into Foursquare at any given time. Two, given that the mall has 2 levels and dozens of stores there was a lot of ground that needed to be covered. Given the large size of the space, the large number of patrons and small number of Foursquare users, the probability of encountering a fellow user was very low. Despite this improbability, I had two near encounters. The first, I believe, was a young Indian girl, across from a sports memorabilia store leaning on the guardrail overlooking the lower level (see image 3). She stood there in pose that mimicked my own, contrapposto with gaze fixed on her phone. I made two passes around the atrium in order but I couldn't confirm that it was she. Simply based on her profile picture, as it cropped out most of the right side of her face, engagement with the subject was out of the question (I was only interested in confirmed users).

The second (see images 4 and 5), entered the mall nearly an hour and a half after my initial check in (I had to check in several times throughout the day). Following his check-in he posted a new photo of himself in the mall. I immediately identified his location. By this point I was on my second lap of both levels of the mall. The first floor of the northern arm of the mall (which contained most of the high-end stores) was decorated with a simulated jungle, complete faux-palms and brush, which lead up to 2 brightly illuminated atria. The user, Garrett Y, had a friend take a picture of him leaning against one of the faux-palms. I received notification of his check-in several minutes after it occurred and was currently on the second level of the north arm. I knew that I had very little time to make it from the second to the first and locate the user. Considering the heightened security in most malls, itwas imperative to remain inconspicuous. I walked like a determined Secret Service Agent attempting to intercept a potential assassin while trying to pass through a crowd without alarming anyone. It proved fruitless, despite my haste I was unable to locate Garrett Y and he left the mall shortly thereafter.

Notes for future attempts:

Choose a smaller, less crowded space. This will make identification of other users much simpler.

Fully investigate the profiles of other users with the hope of acquiring more data and increasing the level of creepiness.

Be vigilant. While the path might be a bit more determined, flaneury is alive and well. There are still many ways that you can work around the increasing restrictions of the digital age.

Image Index:
1.)

Upper Level

Lower Level

The Promenade at Natick Mall

2.)

3.)

4.)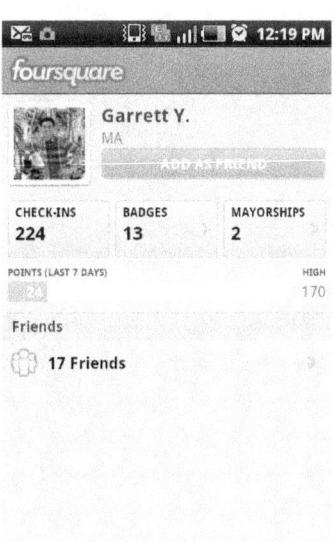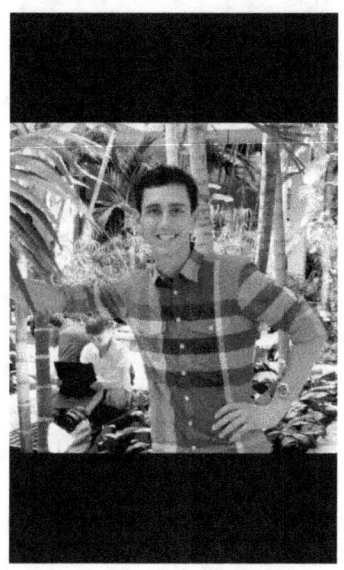

Joanna Tam

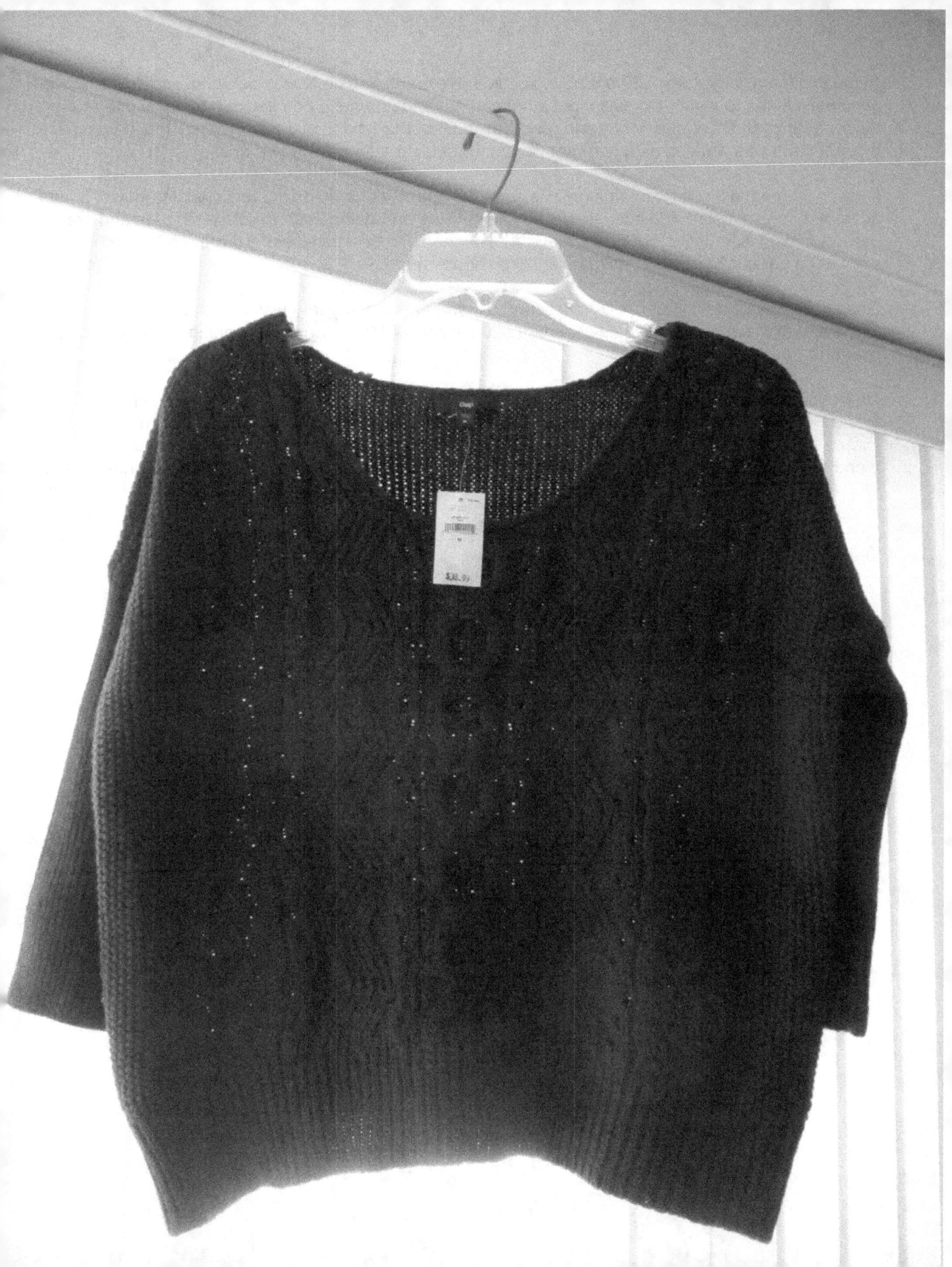

At the minimum wage rate of $8 per hour, I could have made $40 on November 25th. I could then have used my income to watch 4 movies, get a haircut, have Vietnamese noodle soup 5 nights in a row, go out for a fancy Sushi dinner or buy some clothes at Gap. But I didn't make any money that day despite the fact that I was working as a garment worker, or at least attempting to be one.

It was a lot more difficult than I thought. Being at the space alone made me feel claustrophobic. I have never felt so exhausted and intense just by sitting there and doing such simple task. Kids and grandparents looked exhausted too. But I believe a lot of people truly enjoyed being there. After all, who does not want a bargain? I am not going to lie; I like shopping too.

One little girl was looking at me curiously and asked her mother what I was doing. Two women came to me and told me that the sweater was beautiful. After I told them what I was doing, they were disappointed.

On November 18th, I bought a sweater at Gap. It was $38.99 and I think it was more at one point. There was a 30% markdown when I shopped that day. So, I only had to pay $27.29 for this new sweater. I wore it once before November 25th. On Black Friday, I wore the sweater again that morning to my friend's house. I then took it off and started to unravel the sweater. I wanted to unravel the whole sweater before I arrived the mall and start knitting a scarf with the yarn in front of the Gap at the mall. I guess since the sweater was machine-made instead of hand-knitted, it was extremely difficult to unravel with my unskilled hands. It ended up took me the entire time while I was there to barely finish unraveling the sweater. I did not knit the scarf as planned.

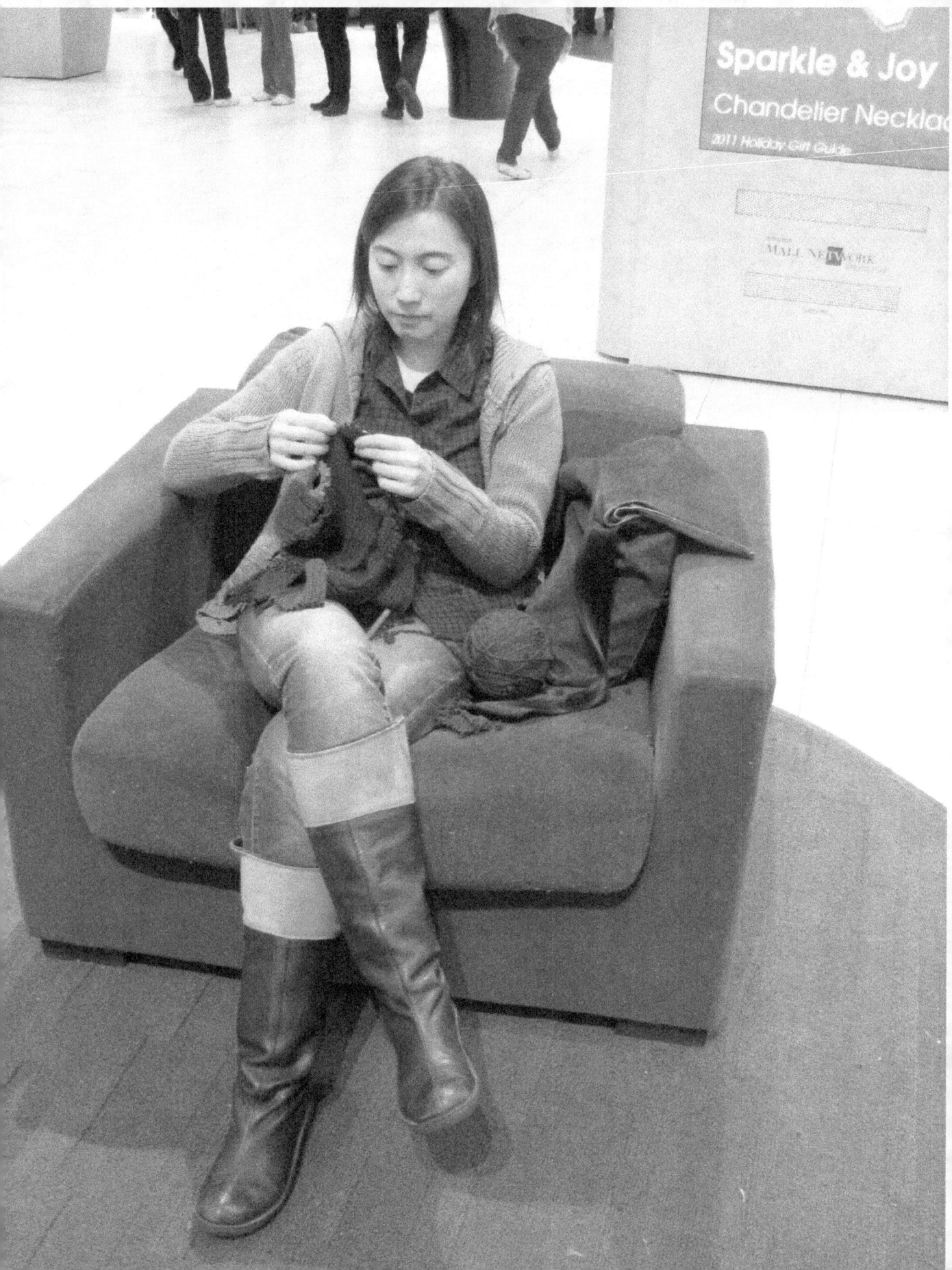

```
            Gap - 2242
         306 Harvard Street
         Brookline, MA 02446
           Tel. (617) 738-6625
11/18/2011                    12:36:30 PM
Trans.: 9184             Store: 02242
Reg.: 003
Cashier: 1729913         Valid No: 8707
                SALE
```

PEPPERCORN CAB 27.29 T
 044577 0002 1 @ 38.99
 Item Discount 30% -11.70
 ADULT 30%OFF

Total Discount -11.70

Subtotal 27.29
Total 27.29
Cash 27.29
Total Tender 27.29
Change Due 0.00

 Unwashed, unworn, or defective
 merchandise accompanied by an original
 receipt may be returned or exchanged to
 any US store within 60 days of original
 purchase. Returns with original receipt
 receive original form of payment for
 price paid. Returns without a receipt
 receive merchandise credit by mail.
 A Mail Check will be issued for
 returns over 5 dollars paid for by check
 or e-check. Valid ID is required.
 One-time price adjustments may be made
 within 7 days of purchase with
 original receipt. Price Adjustment
 will be in the form of a gift card.
 Merchandise ending in 0.97 is FINAL
 SALE. Complete details are available in
 store or at gap.com.
 For exclusive deals and product previews
 LIKE us on Facebook, or text VIP to
 36888 (Message and data rates may apply)
 Customer Copy

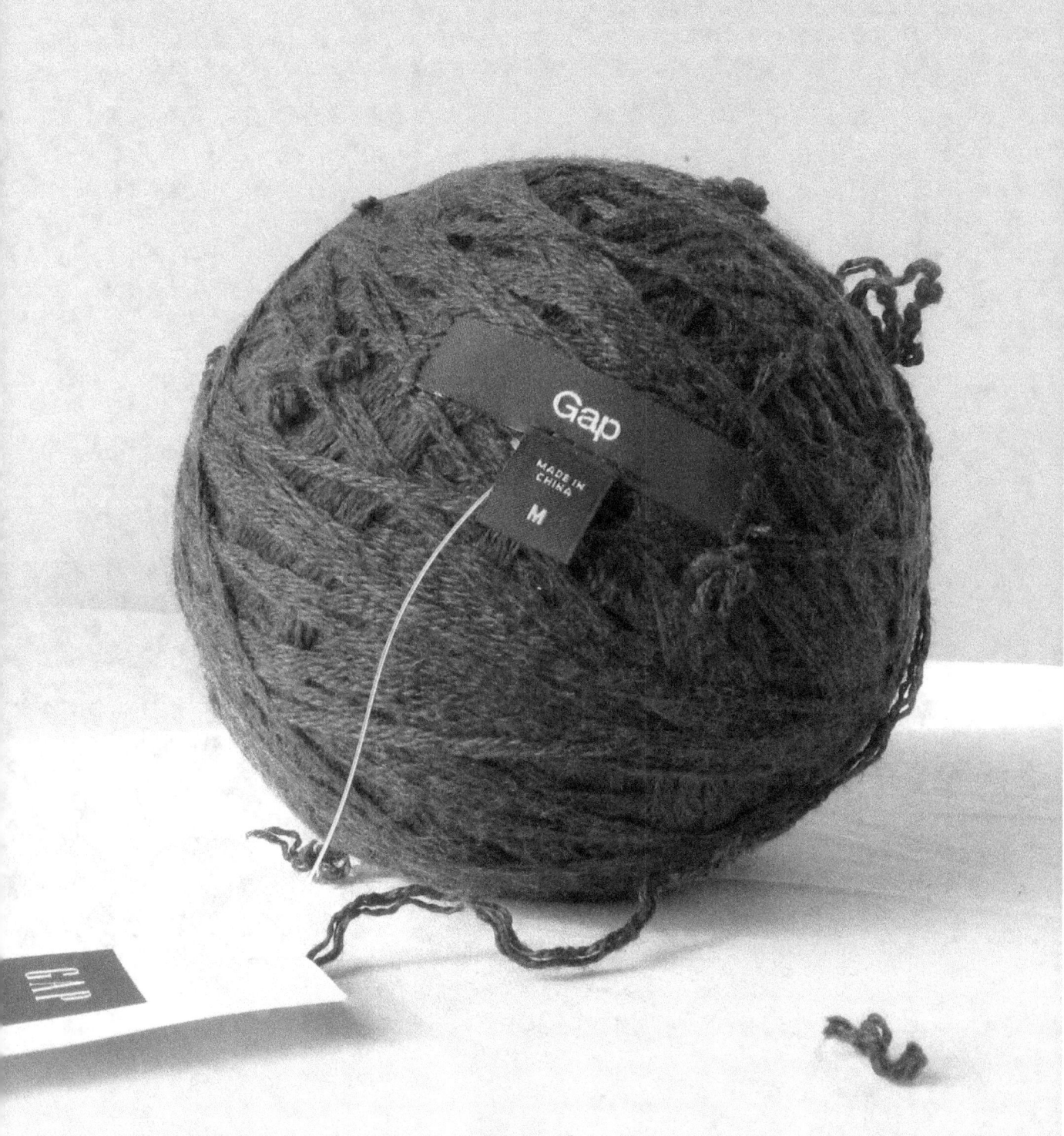

Jordan Tynes

JT's

ZERO $$$ GUIDE TO

BLACK FRIDAY
Edition

NATICK COLLECTION's:
BLACK FRIDAY: November 25, 2011:

<u>Before spending another cent!</u> In your hands is a complete guide to the ZERO COST method of experiencing the Natick Collection's "Black Friday". On this day, exactly one year ago, I scoured the mall for every possible chance of a $0.00 exchange. Ranging from cosmetics and massages to ciders and wines, there are opportunities abound... for FREE! You may ask yourself: "Exactly how far could these 'ON THE HOUSE' occasions take me?" Well, my friend, my answer to that is exactly this: <u>all day!</u> The amount of time that it took me to examine every store, discovering every possible moment of FREEdom, was approximately 8 hours! This is not to say that you need to spend this same level of grueling duration to acquire your GRATIS Black Friday adventure. In fact, this is why I have compiled this COMPLIMENTARY pamphlet. Take this handy directory with you and let it escort you beyond the lesser deals! Let the locations listed within be your first and last stops to your "Black Friday" escapade... FREE OF CHARGE!!!

"Allen Edmonds"
-Last year's featured candy: Tootsie Roll Pops and Rootbeer Barrels (Hint: Look next to the register)-

"Almaari Jewelers"
-Get that old gold ring appraised... No need to sell if it's just for fun! While you're at it, get it polished up nice and right!-

"Apple Store"
-Web-browsing, music-listening, game-playing, photo-taking, video-watching... All in one stop! Then, all these activities can me emailed to anyone in the family without ever leaving the store! (Warning: VERY ambitious sales team is as tricky as warding mosquitos on a hot summer day)-

"The Art of Shaving"
-Feeling a bit scruff? Here's your chance to scrape away the stubble at a shaving station... If you're a bit persistent, you'll come away with a sample of high-end shaving cream!-

"Aveda"
-Try on their "Artistically" "Scientific" approach to cosmetics. Plenty of testers for your hands, too!-

"Bath & Body Works"
-Enter this realm of testers for parts from head-to-toe... Leave smelling of candied fruits until next year!

"Bean Town"
-Are the younguns getting a bit restless? Let them blow off some steam at this state-of-the-art indoor playground!

"Body Shop"
-Even more fruity sample for your hands, face, and hair!-

"Bose"
-Sit back, relax, and enjoy the show! Every 15 minutes or so, you can experience the bombastic sensation of home-theater perfection!-

"Brookstone"
-Ultimate rejuvenation in one of four distinct message-chair experiences! Also a huge variety of toys to keep any kids busy while you relax."

"The Caitlin Raymond International Registry"
-Take a cheek swabbing, give away your name and address, get a free sweater and reusable shopping bag. Don't forget, its for a good cause!-

"Crabtree & Evelyn"
-Basic supply of high-end perfumery. Make friends with the attendants and they'll sniff out the perfect scent for you!-

"Dellaria Salon & Spa"
-Here, you are invited to enter the depths of 'new age' music, soft ultra-sonic lighting, and a free facial mapping! After, ask for a sample of face-wash that fits your skin profile.-

"For Your Entertainment"
-Escape the droning sound of the mall by scanning a CD into the listening station, picking up an headset, and rocking out!-

"Fruits Passion"
-Flu season's just around the bend... Good thing this place has a barrel of water-free hand-sanitizer at their front door!-

"Game Stop"
-Wii! Xbox360! Ps3! Gameboy Duo! You could easily pack away 25 whole minutes of heart-pounding gaming at each of the FOUR demo stations!-

"Godiva"
-Make a lap through this sweet smelling candy distributor and receive a bar of heavenly gingerbread chocolate.-

"Gourmet India"
-Text the number listed on their counter to receive two free samosas!-

"Hallmark"
-Rotating casts of candies to be found in a bowl that sits just beyond the door!-

"Hugo Boss"
-Act as if you would like to buy the most expensive jacket in the store, try it on and they'll get you a glass of wine!"

"Keurig Coffee"
-Hop in the fast moving line for a small coffee, drink up, draw on a mustache, and come back for another!-

"L'Occitane"
-French inspired testers will make you feel as if you're strolling along the streets of Paris!-

"Lego"
-Time to get a little creative at the expansive work station. Challenge your friends to a competition of craft!-

"Love Sac"
-Need another quick nap? Take your pick of comfy seats to settle in to while enjoying the wide screen TV!-

"Lush"
-Clean every inch of you body with a sample designed specifically for each part from head to toe!-

"MetroPark"
-Get down with the live DJ!-

"Nordstroms"
-So many paintings that you'd think you were in a museum! Only, without the entry fee!-

"Origins"
-Demo the hand creams and body scent testers galore... Stay for the samples of tea!-

"Sears"
-Hop on an elliptical, grab a sponsored energy drink, and enjoy the hi-def screening of the latest BlueRay DVD... All at the same time!-

"Sees' Candies"
-Grab a quick candy mint from the bowl as you breeze by this cart.-

"Sleek Med Spa"
-Quick and simple laser-hair-removal consultations... Everything from those prickly ankles to that flowing upper-lip!-

"Sweet Factory"
-Swing by here to snag an extra-large lolli that is handed to you even before enter the shop!-

"Teavana"
-Wait until you get a load of this array of at least six high-quality teas prepared for your tasting!-

"Travelex"
-Come here from afar? Check out the light-up board with all your currency exchange info!"

"Williams Sonoma"
-If your in the mood for a holiday treat, make your way to the center island to find bountiful piles of pumpkin bread, peppermint bark, and apple cider!-

"Yogibo"
-Take the kiddo for a romp around the bizarre landscape of beanbag furniture while you find one for a snooze!-

Keep up the search!
I am certain there are more FREEdoms to be found!

Opportunities for Cosmetics and Perfumes!

"Aveda"
"BareEscentials"
"JCPenny"
"Lord & Taylor
"MAC"
"Macy's"
"Neimann Marcus"
"Sephora"
"Trade Secret"

Food Court Freebies!

"Amazon Bar"
"Master Wok"
"Ruby Thai"
"Sakaru Japan"

JT
2010

Garett Yahn

I went to the Natick Mall two weeks early to prepare for Black Friday. For my project I planned to go shopping. I was thinking of buying some nice Redwing boots or a sturdy pair of oxfords – something versatile that could be the foundation of a new, more sophisticated wardrobe. Now that I am in my Thirties and have a Master's Degree, I feel inappropriate wearing sneakers and ratty clothes. To my dismay I didn't find a single pair of Redwing Boots in the Natick Mall, but I did discover the Allen Edmonds store. Allen Edmonds is a purveyor of upscale dress shoes handmade in my home state of Wisconsin.

I was the only customer at Allen Edmonds at the time and received fantastic service. The salesman measured my feet and talked me through the selection process. The shoes at Allen Edmonds range in price from 250.00 to 500.00 per pair so choosing between the different styles caused me some anxiety. I explained my situation to the salesman. I told him that I was just beginning what I hoped would be a long, distinguished career as an art professor and that I needed a pair of shoes suitable for interviewing and eventually teaching. Because I don't have much money they would need to be both comfortable for work and nice enough to wear to the occasional formal event – at least until I could afford to buy another pair. The salesman suggested a plain-toe, lace-up called The Kenilworth. The particular style he suggested was made of burnished calf skin that shifts in color from a deep brown to almost black near the toe. This shoe could be dressed down with jeans and a blazer or worn with a suit, and because of the deep color at the toe, even worn with black. I tried the shoes on. They fit great and were decidedly comfortable but I wasn't convinced that they were the right shoes. They didn't look great with my clothes and felt a little old for me. I had another look around the store but didn't couldn't decide on a different pair. The Kenilworth satisfied my main objective of versatility better than any of the other styles. I asked to have the shoes set aside until I came back – maybe they would look better with a different outfit. The cost of the shoes plus the care package came to 375.00. I rationalized the expense because they were high quality and would last and because they would also serve my Black Friday art project needs.

Of course, I couldn't pay for the shoes at the time. My plan was to earn the money working odd jobs in the two weeks before Black Friday and make my purchase then. I already had a couple of jobs lined up and didn't have any trouble finding a couple more. At the time I was working as a studio assistant for an artist in Watertown, MA – he had me fix a handrail on his front staircase during my lunch break and paid me 60.00. Later that week I took an old couch from a friend's living room and hauled it away for 25.00. The next week I helped someone clean out a garage for another 120.00. Finally, I labored for friend's landscaping company for 75.00. Unfortunately the 280.00 I made was not enough money for the shoes and care kit. I decided to proceed with the plan anyway. Maybe Allen Edmonds would let me put the shoes on layaway.

I wore the best clothes I owned to the Natick Mall on Black Friday. I didn't want the sales people at Allen Edmonds to think that I wasn't serious and I wanted to be sure the shoes would look good with my existing wardrobe. My best clothes were a new pair of Levi's 505s and a button-down shirt with a tie. I wore sneakers with that outfit. The store was much busier on Black Friday so I didn't get the same attention I had received two weeks earlier. I tried on the Kenilworth and it became clear immediately that either I needed nicer clothes or to select a different pair of shoes. I asked to try on a couple of different styles. As I hemmed and hawed pacing the store and standing in front of mirrors I grew more anxious and the sales person became less accommodating. I asked if I could try on a third pair – a black cap-toe blucher – my size was out of stock.

At this point I felt pretty awful and potentially exposed. I decided to take the opportunity to leave. I thanked the salesman and didn't ask about lay-away. I took 20 dollars of my odd-job money for a massage and some Taco Bell.

I decided later that perhaps I was going too far by purchasing such an expensive pair of shoes. Maybe I should buy a pair of boots instead – something that would work better with my wardrobe. I could come back to Allen Edmonds when I was ready to get married. It didn't matter, I couldn't even buy boots. I spent 100.00 of my savings on rent a few days later and sunk the balance in a plane ticket home for Christmas. My quest to dress more like a grown up is still alive though. I have taken to reading men's fashion blogs which has given me the confidence to make a few quality purchases. At a Goodwill store a few weeks ago I found a used pair of Allen Edmonds McTavish wing tips for ten dollars. They need new soles and are two sizes too small but I bought them anyway. I'll fix them up and display them on my mantel. Or maybe give them to my brother.

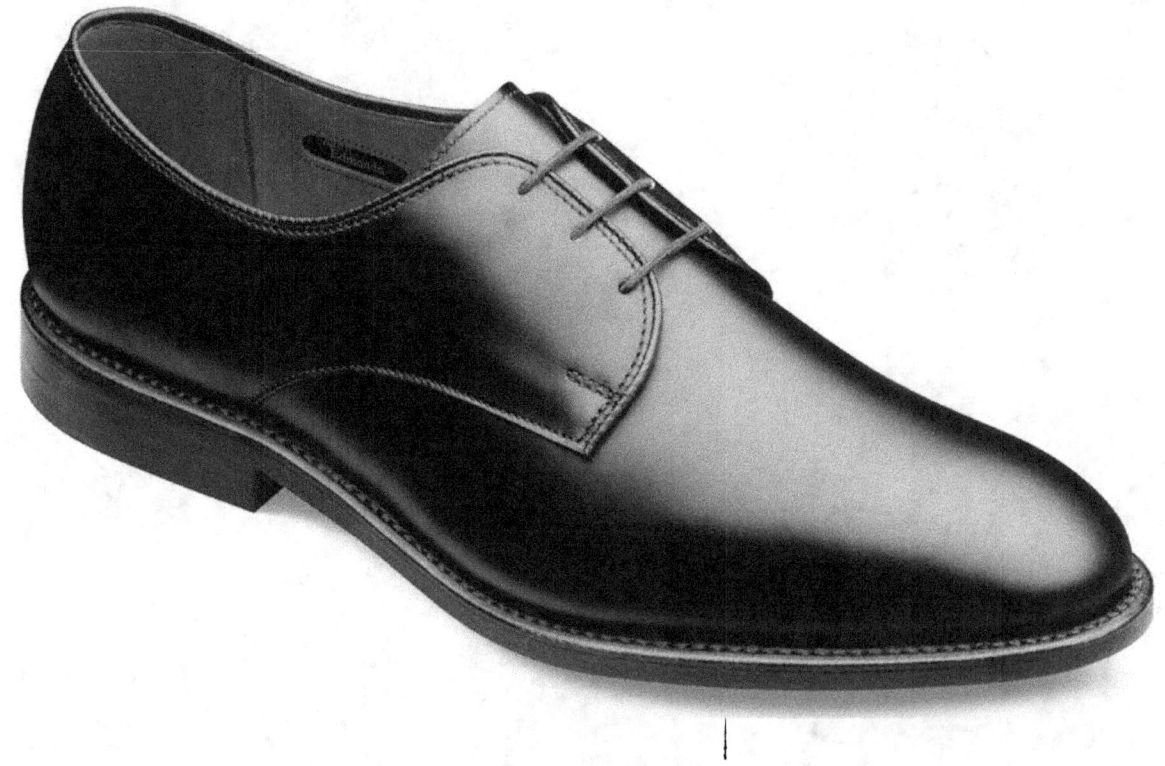

The Kenilworth

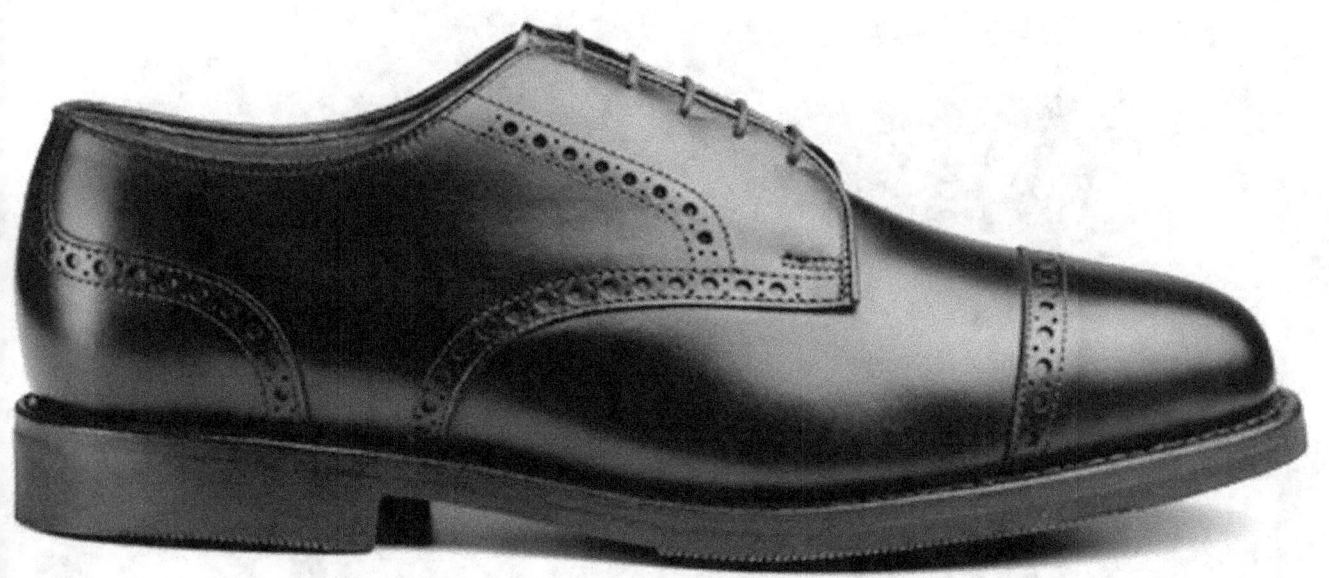

The Benton

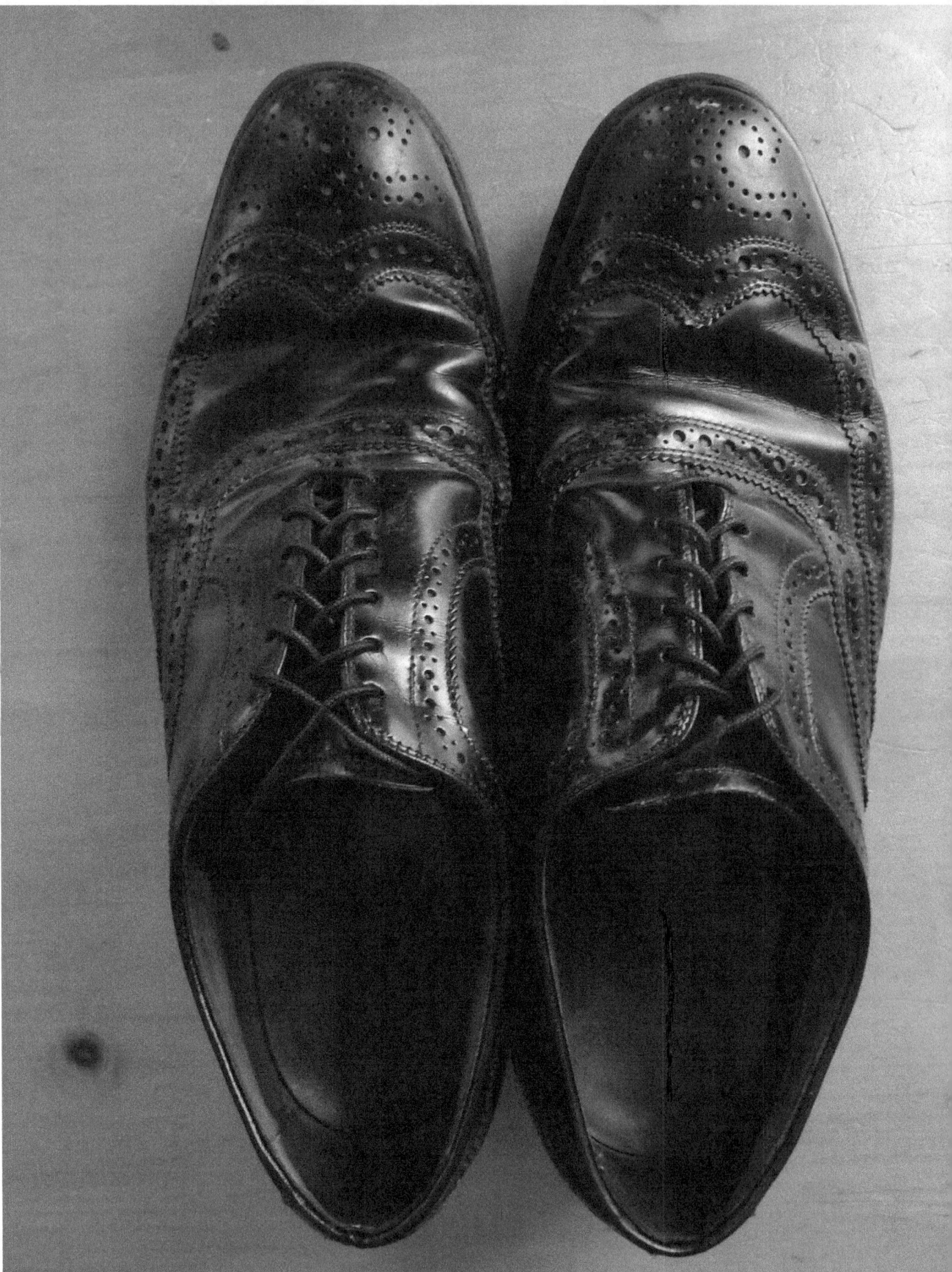

www.ingramcontent.com/pod-product-compliance
Lightning Source LLC
Chambersburg PA
CBHW080921170526
45158CB00008B/2186